E.E.R.K.
Energy Emergency Repair Kit

E.E.R.K. Collective

FORDHAM UNIVERSITY PRESS NEW YORK 2024

Fordham University Press has no responsibility for the persistence or accuracy of URLs for external or third-party Internet websites referred to in this publication and does not guarantee that any content on such websites is, or will remain, accurate or appropriate.

Fordham University Press also publishes its books in a variety of electronic formats. Some content that appears in print may not be available in electronic books.

Visit us online at www.fordhampress.com.

Library of Congress Cataloging-in-Publication Data available online at https://catalog.loc.gov.

Printed in the United States of America
26 25 24 5 4 3 2 1
First edition

This book is dedicated to
all of our loves and losses.

Contents

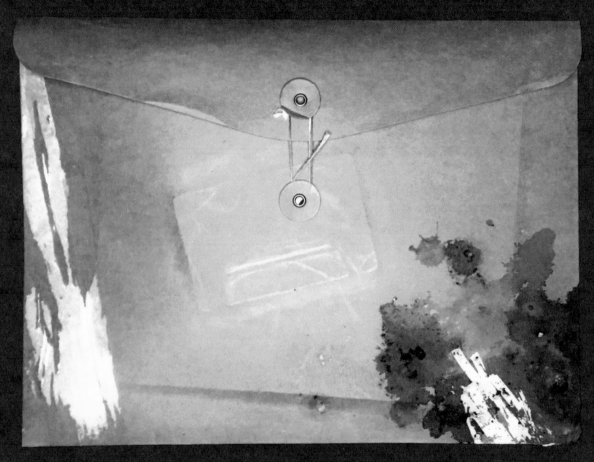

fig. 1

Introduction

This volume preserves the surviving fragment of the Energy Emergency Repair Kit, an obscure talisman from the lore of climate catastrophe. As readers will see, the textual material reprinted and rebound here not only confirms but indeed exceeds every rumor of that spectral work's unnerving oddity, counterfactual weirdness, and strange cunning. Could its circulation now, even in partial, fractured form, reanimate and reactivate some slender hope going forward for energies beyond emergency, a prospect long dormant if not completely dead? Such is the bid– even the burning ambition–of the present publishing venture, however quixotic it may seem.

The material presented here constitutes the most coherent, least cryptic portion of a dossier delivered anonymously by courier at the front desk of the Annex for Speculative Innovations in Futurentropy mere hours before that beleaguered venue's final closure. How ironic that such a telling bequest–one so relevant to mandate and vision–should come to ASIF just when the cumulative toll of grinding budget cuts proved terminal for its institutional continuance. The mystery surrounding the hand that made this gift has only encouraged surreptitious whispers among us ex-ASIF staff about the dossier's provenance. Was it recovered, as some speculate, during recent excavations at the ruins of the Intergovernmental

Panel on Climate Change Theme Park on the outskirts of Geneva? Or did it emerge, as others wonder, from a time capsule found when the last of the ancient semi-submersible drilling rigs was finally carved apart to harvest its metal for scrap? Whatever the ultimate truth–most likely undiscoverable–the fact remains that the contents of the dossier themselves unfold puzzle upon puzzle and void after void.

Inside a stained and mangled envelope was a jumbled cluster of items: the textual fragment offered here; the charred remnant of a memorandum (date partially redacted) prepared by "E.E.R.K. Collective" and addressed to "Incident Actuary Pro Tem, Hysteresis Outreach, Decomp Committee" on the cryptic subject "Once more, with feeling"; a series of obscure images, seemingly a type of primitive photograph; and a rectangular polyhedron made from a crude form of plastic (so much more rigid and less forgiving than the advanced micro-synthetics and perma-polymers that saturate everything everywhere today) with some kind of shiny ribbon, likewise plastic, unspooling from within (figures 1 & 2). The text is a head-scratching document–but it is roughly legible and, what's more, provides select clues that shed some light, however tenuously, on the burnt memo, the images, and the ribboned polyhedron as detailed below.

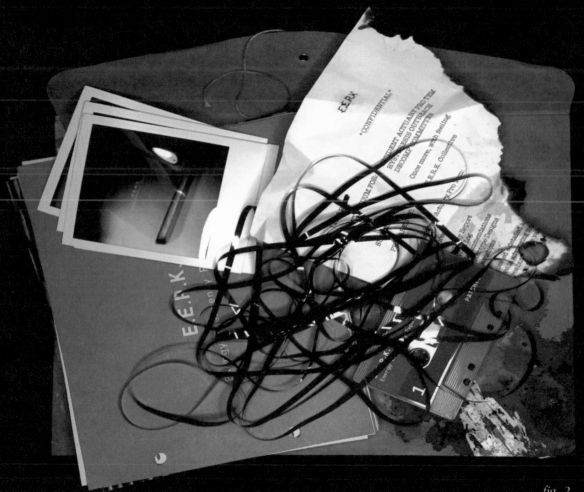

fig. 2

Foremost among such clues are the several references made in the text's appendices to "cassette tapes," which research has confirmed were once a popular type of analogue medium for recording sonic signals: ubiquitous, at first, as a means of disseminating information and entertainment to the masses, then persisting, even when technologically outmoded, in underground circles for use in more bespoke and clandestine communicative rites. These determinations, coupled with a very fortuitous pawnshop find of a dusty but still-functional device for the playing of such cassettes, have enabled the recovery from the unspooled ribbon of sounds now transferred to a more stable and usable digital platform. Interested readers can scan the Quick Response Code at the end of this introduction and, provided all technological requirements are met, listen to these sounds themselves. The noises compiled are frankly baffling, yet hauntingly beautiful and memorable for all that: what an earlier generation might have called *earworms*–bewitching and arresting, a sonic spell for the energetic exhaustion elicited by the text's strange currents. Unfortunately, the process of sonic recovery damaged the cassette and its ribbon irreversibly, beyond all repair.

The text mentions "Team E.E.R.K." or "the E.E.R.K. Team" numerous times in passing. Is it too rash to suppose that these monikers slyly riff on the burnt scrap's E.E.R.K. Collective–and so to attribute the latter authorial agency? Rashly or not, the present publication embraces this risk by naming the E.E.R.K. Collective as the manual's composite author. The scorched memo's other mysteries are best left well alone

A single, teasing reference early on in the text to "[t]he kit's tried and true ring-bound technology," meanwhile, helps in beginning to grasp the import of those images that seem to show the Energy Emergency Repair Kit in something like its original state and format (figures 3 & 4). Cross-referencing text with image here will suggest that, perhaps, the cover used to enclose the text's pages and protect them from damage by the elements was what old-time stationers' catalogues call a *ring binder*, designed to gather loose-leaf papers so as to keep them together while also permitting their ready removal and rearrangement. This hunch makes sense of the kit's covering as depicted in the images–and it also helps to explain why each page of the textual fragment is punched with two holes, identically spaced.

A last textual clue is admittedly more speculative still. Note how the text exhibits a recurrent, not to say obsessive, fascination with *mycelium*. Mycelial

fig. 3

fig. 4

references abound across these pages, shooting out again and again and again in ways that will suggest the signal importance, for the makers of the kit, of mycorrhizae as energetic trope, medium, material, and perhaps even muse. Is it then possible that the off-white rectangular casing attached to the bottom back cover of the binder and serving, to judge from a couple of the images, as a kind of housing for the ribboned polyhedrons or "cassette tapes" was itself *made from mycelium*? The poor resolution of the images in question renders the visible evidence maddeningly inconclusive–but the casing's tone and texture as glimpsed in these pictures do tempt such reckless speculation (figures 5 & 6). (The mystery is only compounded by the exploded-view diagram appearing early in the text, which implies that the casing is "Ganoderma Lucidum (mycelium)" . . . yet shows the casing as pink, not off-white!)

Notwithstanding the clues outlined here and the conjectures they may entice, the dossier as discovered only raises more questions than it answers.

1) The kit lists by name what it calls its "Technical Writers, Designers, and Schemers": presumably members of the E.E.R.K. Collective mentioned in the burnt memo and credited, in the present publication, with the manual's authorship. But who exactly were these makers? And what did they hope to achieve with their decompositional aesthetics? What did they intend by seeking, as they write early on, "to *deviate the designs*"?

2) If the kit's text served as a kind of energy emergency response manual, as repeatedly averred in its pages, then a manual to or for . . . what? With what hope or purpose did it *how-to*? Who were this manual's users, whether intended or desired or unimagined–and did it ever reach them? If not, why not? But if so, then in what ways and to what ends did they end up using or misusing or otherwise activating the kit?

3) What happened to the ring binder covering? Why is it missing? Did it get separated from the manual text in an unfortunate yet mundane instance of file mismanagement? Was it removed and replaced, through an act of technophilic hubris, with some replacement binding that, while designed to make the kit more efficient, proved inadequate in the event to meet the demands of whatever habitat the kit went on to join–or indeed the demands of the kit's own recalcitrance? Was the kit the target of some attack or sabotage by unknown agents fiercely opposed to its modes of *howing* and *toing*,

fig. 5

fig. 6

with the textual fragment itself somehow managing, improbably and marvelously, to evade destruction? Or was the manual *itself the sabotage*–separated of necessity from its more cumbersome covering apparatus in order to circulate furtively, from hand to hand to hand along subterranean channels, as a hyphal kind of samizdat before finally landing on the front desk of the doomed ASIF?

4) Last but not least, why and when did the mycelial insert, if indeed it was mycelium, grow over one of the cassettes, as some of the images seem to show (figures 5 & 6)? Do those images capture the end, the last inertia, of such growing– or do they figure a process in media res, with what's maybe mycelium still very much alive and only beginning its longer, branching work? If the latter, then does overgrowth itself imply an answer to all the other questions here posed? Did mycelial energy consume the insert itself, along with the binder and whatever else was nearby, in an epitome of *decomp poesis*? Except then . . . *why do the manual and unspooled tape remain?*

All these questions, if doubtless thrilling, are–as the last sequence in particular will confirm–also and increasingly bruising to mind, to body, and to

spirit. They raise the entirely plausible suspicion that dreams of solution, of ultimate or total or even partial knowing, cannot–can never–compete with the proliferative, multi-species powers of subtraction, of erasure, of composition-by-decomposition and growth-through-degrowth as vital, generative means of care and repair. There is finally no avoiding the void. Rather than persist in striving, with every good intention, to determine the indeterminate and to decide the undecidable, then, it seems better to conclude this brief introduction on a more cautiously secure footing with some less philosophically fraught remarks about obscure terminology and miscellaneous errata.

Note on Terms

Whether appearing frequently or seldomly, some words encountered in the Energy Emergency Repair Kit may, for reasons of usage or coinage, not have much currency today. What follows, then, is in keeping with the kit's spirit of "user-friendliness" a sort of *best-guess glossary* prepared with the able assistance of ASIF's Guest Amanuensis Bot® and intended to create terminological openings through which readers might amplify their enjoyment by boosting their engagement and entanglement with the many conceptual filaments that sprout across the manual's pages.

Altergorithmanalysis, n. According to obstinate rumours from the underworld, a slang term, bordering on obscenity, for an obstreperous vernacular ritual for decomposing all ontologies and analogous novel plastics for filling voids. Suspected of involving frenzied hyper-kinetic dancing conjectured to mobilize collectivities of zeroes into encircling every One in any code. ASIF's attempt to test this theory resulted in instant evacuation, leaving the server room shrouded in blue smoke, and has been filed as inconclusive.

Anekntavda, n. A codex found in the southern midden of the 6th stratum of the Great Equatorial Plastic Scab at a depth of approximately 1776 metres preserves a reference to "a subtle and sporadic gift left by the Ancient Jains to the Peoples of the Pluriverse" in a collection of 365.25 heavily redacted pages where the obscure and archaic term ***anekntavda*** re-appears thirteen times. The intoxicated philosophical raging and rambling that throbs and strains against the redaction suggests a terrifying, redundantly proliferating, metaphysical argument defending the entwined theses that whatever is real is infinitely plural and that infinite plurality is the atomic reality of finite common-being. The insistent, incessant proliferations further disperse an archaic and quaint ethical doctrine named in the ballistosporic sheaf as *ahimsa*, translated as non-violence, or care, by ASIF's transformers, repeating here differently the simple-hearted ethos of all ghoulish Peoples without History or without the rule of law able to secure the identity of property and productivity.

Ecological debt, n. A driftpile of burnt placards and shredded dissertations retrieved from the circumpolar boreal ash-pit is rife with references to the term "ecological debt," which makes enigmatic appearances in the manual as well. Triangulation via radio carbon dating, dendrochronology, and

back-propagated divination confirms the coeval provenance of the manual and this archive during the antediluvian Age of Chaos. Charcoal analysis combined with Bayesian regression, sentiment analysis, and other text mining methods revealed that "ecological debt" was a concept invented and refined by environmental justice movements in the Global South to name the incalculable accumulated violence of calculated pillage underpinning progress, development, and the racial-capitalist [see below] form of wealth. Until this long studiously ignored idea was finally extirpated from civilized discourse, the concept served as the fulcrum from which the scales of (in)justice were suspended.

Emoji, n. Tiny image or symbol used to convey graphically myriad and often quite complex ideas and emotions. Symbologists suspect that the emoji first appeared in a failed and futile attempt to make the inbox [see below] bearable in some way.

Inbox, n. Cumbersome message storage mechanism used in cloud computing's infancy. A millstone around the collective necks of hive-mind workers during that dark time.

Karaoke, n. This one defeats our experts. Its appearance in the manual suggests it was a noun, serving to name who knows what. On-the-go snack item? Oxygen substitute? Kitchen gizmo? Severance package? Game of chance? The mysteries proliferate

Kleptocrat, n. Nonce word of dubious provenance. Conceivably favored for use at bonfire singalongs by agitators and provocateurs on account of its potent rhyme- and half-rhyme-ability with myriad terms such as *swat* and *shat* and *corrupt* and *splat* and *guillotine*.

Mega-mall, n. A giant shrine for the purchase of all manner of goods and services. Necessary, one infers, because medullary implants did not yet exist, meaning that people could not make things come to them automatically and so had to go to things–*in situ*, as it were.

Oligarch, n. Recalcitrantly crepuscular. To judge from the manual's use of this term, it may have something to do with *oil guards*, whatever those were. Attempts at determining a precise definition using ASIF's trusty idiolectograph managed to blow out the machine's optical spectrometer and set its teletype dispenser port on fire, leaving guesswork as the only recourse. It is worth noting that *oligarch* is an anagram for *hair clog*, perhaps intimating a connection with plugged drains . . . ?

Petroculture, n. A portmanteau for the culture of–which is to say fueled by–petroleum. What few sources survive offer two interrelated uses of the term: to convey the idea that petroleum-as-fuel was not merely technical but had manifestly cultural dimensions as well; and to advance the insight that, in a petroleum-fueled system, oil saturates everything–even practices (e.g. boogieboarding), habits (e.g. poutine for lunch), beliefs (e.g. climate not changing), and desires (e.g. donut love) that might initially seem to have nothing to do with matters of energy. Strange to think that such a term was once useful!

Racial capitalism, n. All computational records that might have provided clues to the meaning of this term seem to have been deleted (apparently over and over again). Historical proprietary satellite imagery run through our advanced noise reduction filters suggest that its meaning might have something to do with where nuclear waste from the fifth industrial revolution has been stored, perhaps in some sort of cage or camp, though ASIF technicians note that the white balance mask and filter tools become unpredictable in extreme climates. The manual's occasional preference for the compound neologism *racial-fossil capitalism* might lend credence, however tenuous, to these speculations.

Sleep, n or v. Opaque in meaning. Conceivably denotes a more sustained and intensified version of the long ~~outlawed~~ outmoded practice of *resting*.

Technoutopian, n. Borderline malapropism (and manifest slur) that, as used in the manual, seems to associate technological progress with fallacy while implying the possibility of dystopian technological outcomes. As doctrine teaches, though, one does not have to embrace technophilic excess to celebrate technology.

Virtual sabot, n. Wooden shoe, good for sabotage. Doesn't really change, whether actual or virtual–though it's an open question if the virtual version is as good for sabotage. ~~Guest Amanuensis Bot® jokes that you should give it a try, you've nothing to lose but your chains ha ha!~~

ZEV, n. Evidently an acronym–but for what is unclear. Zen Ease Virtue? Zesty Edible Vegetables? Zealot Extrovert Ventricle? Quite the puzzle, this one. The idiolectograph would come in handy here, were it not a smoking wreck.

Errata

What follows is a list of apparent glitches in the text of the E.E.R.K.–whether uncontroversial or rather more fraught remains for the reader to decide. Either way, they will tend to underscore the manual's basic weirdness and, as such, might force us to wonder what, exactly, is error. Is all error? Is error all? Can error ever find repair? Should it? Is error actually care?

Preface, n.p., ll. 15-22, for "IN THE EVENT . . . DAMAGE DONE" read "Disclaimer now void."

p. 4, l. 12, for "Tape 2: Fixes" read "NOT IN SERVICE."

p. 37, ll. 8-24, for "███████████████████ ████████████████ etc etc etc" read "Caveat emptor."

p. 50, col. 2, ll. 9-12, for "CAUTION . . . BLADE" read "ASIF is not liable for accidents that occur in the deployment of NSOPs."

p. 51, "SUPPLY LIST," beneath "Unopened Box of Chocolates" image, imagine a hidden "Suitcase of Cash" image; trust that it will stay there undiscovered until you can grab it; beware the proofreader.

p. 52, l. 5, for "**no guns–no exceptions**" read "The gun is the exception."

p. 56, ll. 27-33, for "DISCLAIMER . . . repair" read "Wanna bet?"

p. 81, ll. 7-8, for "total ██████████████████ for ███████████████ and ████████████████ ████████" read "Total frenemies forever."

p. 81, l. 26, for "██████████████████████ and ███████████ on" read "Haste makes waste."

p. 83, Tape 2: Fixes, for redactions–"██████████████ etc etc etc"–insert fave playlist, found sounds, fleamarket medley, etc etc etc.

E.E.R.K.

Energy Emergency Repair Kit

Edition: __4__ / __30__

This manual has come to life through energy that
channels disturbances in the magnetosphere, solar winds
and charged particles, all the many colliding oxygen
atoms that cause the rare red aurora. Its multitudinous
contents are dedicated to care-givers, repair-makers,
and energy-transformers past, present, and future, and
especially to all E.E.R.K. friends and family, including
that family's newest member, little Kets'ŏk!

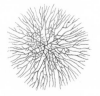
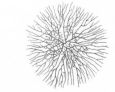
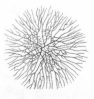

Acknowledgements

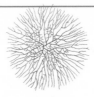

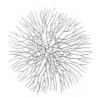

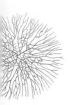

THE WORK FOR THIS PROJECT WAS CARRIED OUT ON TURTLE ISLAND. WE ARE NOURISHED BY THE ENDURING HOSPITALITY AND WISDOM OF ALL ITS SOVEREIGN INDIGENOUS INHABITANTS.

AS THIS PROJECT EMBODIES THE INNUMERABLE SOCIAL-ECOLOGICAL CONTRADICTIONS OF CONTEMPORARY RACIAL CAPITALISM, WE REMEMBER THAT THROUGH VARIOUS AND OVERLAPPING INSTITUTIONAL, NATIONAL, AND TRANSNATIONAL AFFILIATIONS WE HAVE INCURRED ECOLOGICAL DEBTS WITHOUT MEASURE FROM THE ACCUMULATED VIOLENCE OF ENVIRONMENTAL RACISM AND ECOLOGICALLY UNEQUAL EXCHANGE THROUGH THE EXTRACTION, PRODUCTION, DISTRIBUTION, CONSUMPTION, AND TOXIFICATION OF LANDS AND THEIR PEOPLES AROUND THE WORLD. WE THEREFORE AFFIRM AND COMMIT OURSELVES TO THE PRINCIPLES OF ENVIRONMENTAL JUSTICE ADOPTED BY THE FIRST U.S. PEOPLE OF COLOUR ENVIRONMENTAL LEADERSHIP SUMMIT HELD OCTOBER 24-27, 1991 IN WASHINGTON D.C. SEE THE ENVIRONMENTAL JUSTICE / ENVIRONMENTAL RACISM LINK AT EJNET.ORG FOR THESE PRINCIPLES.

Preface

This *Energy Emergency Repair Kit (E.E.R.K.)* offers a host of situated activities and speculative probes designed to respond to today's energy emergencies. Intermingling diagrammatic designs with instructional convolutions and perplexing protocols, the kit provides a non-programmatic yet highly pragmatic collocation of materials for *navigating*, *communicating*, *operating*, and *un-doing* the investments that have come to overdetermine energetic relations in the past, present, and future.

Triggered most immediately by the pandemic moment circa 2020, with its strangely intermittent and inscrutable convolutions of petrocultural business-as-usual, this kit reflects and reckons the long-roiling and fully chronic *energy emergency* orchestrated over several centuries by racial-fossil capitalism's mass production of injustices. Situated within today's petrocultural ubiquity, but also highly skeptical of the facticity of such claims, this repair kit positions *energy* as more than just a resource to be exploited and managed, more than an infrastructural obstacle to overcome, more than fuel for the nightmares that lie ahead (or that are, in too many cases, already here). Energy is life. Energy is death. Energy involves investments and divestments--of desire; of affective connection; of interspecies interdependence; of care and repair.

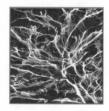

With this in mind, the thinkers and makers in Team E.E.R.K. have conspired with *multitudinous experts*, from mycelial decomposers and speculative designers to ferromagnetic attractors and recording engineers, to create a provocatively user-friendly guide to various modes and methods for grappling with the pressing energy scenarios that burn today and may flare tomorrow. While our mycelial comrades have influenced our understanding of structure, reciprocity, and decay, our sonic agents, at least when we can hear them, have helped us to develop approaches to mediation and listening in these noisy times. In behind such collaborative collegial effort lurks an agglomeration of fibre-optic cables, server farms, and online platforms vital to the development of this repair kit and to the relations enabling its manufacture. And remember that at every point the kit will concentrate low alongside high levels of energy spent on and vital to its creation: *the bonds of endeavour; the glow of affection; the pulse of attunement; the drive of subtraction; the charge of uncertainty; the resilience of exhaustion; the obstinacy of making do; the shadow of fossils; the pull of futurity; the zeroes and ones; the force of an otherwise.*

IN THE EVENT THAT THE REPAIR KIT ITSELF BREAKS OR BECOMES OTHERWISE ALTERED IN CONDITION THROUGH THE WIDER EFFECTS OF EMERGENCY AND/OR HANDLING (HUMIDITY, MOLD, WATERLOG, FIRE, ACID HYDROLYSIS, ABSORPTION OF POLLUTANTS, STARVING SILVERFISH AND BOOKLICE, FRENZIED OVERSHARING, ETC.) PLEASE INFORM TEAM E.E.R.K. OR THE MANUAL'S PUBLISHERS AT SPECULATIVE ENERGY FUTURES ABOUT THE NATURE AND EXTENT OF THE REPAIRS REQUIRED TO RESTORE THE KIT AND ITS COMPONENTS. WE WILL MAKE EVERY EFFORT TO PROCURE A PATCH OR FIX APPROPRIATE TO THE DAMAGE DONE.

Table of Contents

5. RITUAL MAINTENANCE

APPENDICES

INTRODUCTORY MATTER

1.1
Introduction

The methods of *care and repair* in this collection will seem familiar to some and novel to other readers. Although not necessarily unique to the unfolding energy emergency, they are expertly attuned and calibrated to the current conjuncture, making their designs particularly conducive, the E.E.R.K. Team believes, when addressing today's vexatious energetic problems, whether long-predicted or completely unforeseen. For the purpose of repair focal to this kit, those methods imported from other, more benign contexts have been deformed and transfigured as required to adequate the opacity of the situational calamity to which they correspond. The kit's tried and true ring-bound technology, meanwhile, allows and encourages the removal of any particular design for fast, easy redeployment in alternative caring-repairing activities during as-yet unanticipated future emergency scenarios.

Materials in this kit demand active engagement and therefore *energetic expenditure*, but none of them has a single, prescribed mode of use. In most cases they invite activation as readily by the lone adherent repairing in solitude as by the acolyte swarm caring in common. Very little initial practical skill is required for the performance of this repertoire; in fact, intuitive capacities for bodily altergorithmanalysis, fungal networking, speculative negentropy, etc. may well arise from the ritual practice of these methods as part of a modular *compose | decompose* programme of study.

Every attempt has been made to *deviate the designs*, in both text and image, from the abyssal givens of petrocultural common sense.

- The illustrations and diagrams as prepared aim to provide maximum presentation within a limited space, and also to supply a 'picture' of what is almost always unpicturable.

- Turning away from familiar modes of fixing that, in working hard to further the damages done, hardly work to actually address today's energy emergencies, the care-and-repair programme offered here turns instead toward refusal, toward saying no or, at least, "who knows . . . ".

- Graphic simplicity encodes an ethos of borrowing alongside an art of reuse, misuse, and refusal that, together, will encourage the proliferation, at scale, of formal and informal acts of care and repair by which to counter the deadly mythos of perpetual accumulation and growth driving the energy emergency.

- The conditions, methods, and practices in what follows, then, involve the stationing of weird calibrations and radical approaches to work: "working at not working" is the spectral mantra of this kit and its speculative conjectures.[1]

1. See Sarah Sharma, "A Manifesto for the Broken Machine," *Camera Obscura 104* 35, no. 2 (2020).

1.2
Inside This Kit

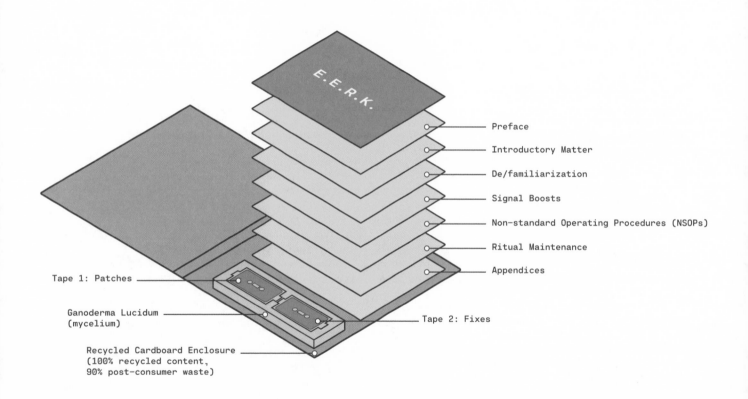

E.E.R.K.

Preface

Introductory Matter

De/familiarization

Signal Boosts

Non-standard Operating Procedures (NSOPs)

Ritual Maintenance

Appendices

Tape 1: Patches

Ganoderma Lucidum
(mycelium)

Tape 2: Fixes

Recycled Cardboard Enclosure
(100% recycled content,
90% post-consumer waste)

1.3
How to Use This Kit

This *Energy Emergency Repair Kit (E.E.R.K.)* aims to provide a *user-friendly* guide to responding to the energy emergencies gathering force and speed across ecological, social, and mental life today. Do not mistake friendliness for familiarity, conformity, or complicity, however: this kit confounds the assumption that today's energy emergencies can be met with formulaic responses and straightforward solutions as well as the demand that these emergencies be resolved with methods of wealth and power that thrive on emergencies. Instead, this kit channels and amplifies the resonances of ancient wisdoms, denied truths, and marginalized voices by offering an experimental site for engaging in speculative energetic encounters that necessitate the insubordinate formation of unlikely alliances, unthought solidarities, and strange friendships.

As a feature and texture of this kit, user-friendliness, counter to its common valence, does not indicate something that is easy to learn, obvious in its application, uncomplicated to deal with. In opening onto repair, such user-friendliness is weird: provocative as well as generative, estranging because invigorating. The kit's user-friendliness, then, aims to proliferate speculative germinations while also transforming both the sense of usefulness and the modes of relationality that have come to limit emergency responses.

As such, users of this manual--or friends, dare we presume--may enter as their intuition, time constraints, and/or energy levels dictate. Some ways to begin navigating this manual and its mushrooming contents include, but are not limited to:

- *the comprehensive approach:* read front-to-back (best done in concert with Tape 2: Fixes);
- *the contrarian approach:* read back-to-front and bottom-to-top;
- *the selective approach:* peruse the Table of Contents and follow your heart's (or brain's or belly's) desires;
- *the visual interest approach:* flip through the manual until an image grabs your attention, holds your eye, jolts your memory, sticks in your craw;
- *the pressing problem approach:* use the manual as a patching agent; pick and choose the sections most appropriate to the emergency at hand (best done in concert with Tape 1: Patches);
- *the random approach:* roll a die, toss a coin, close your eyes and point, stick a pin, throw a dart, and/or use any other chance-making strategy that you favor or chance upon;
- *the fixational/redundant approach:* transcribe with pen, pencil, and/or keyboard every typographic, diagrammatic, and illustrative mark in the manual as faithfully as possible;
- *the marginal approach:* annotate, supplement, and/or deface the manual's text and/or imagery with pen, pencil, crayon, lemon juice, etc;
- *the miscellaneous approach:* thematic; allegorical; anagogical; ritualistic; hermeneutic; recitational; numerical; counterintuitive; close; at a distance; on the surface; in the depths; reparative; paranoid . . . etc etc etc;
- *the refuse approach:* refuse all of the above; time's a-wastin'; enough of this garbage.

DE/FAMILIARIZATION

2.1
Getting to Know Your Energy Emergency

I. The Energy Emergency *is* what the Energy Emergency *does*.
 A. What the Energy Emergency does can be felt far beyond energy futures indexes and climate modelling; this emergency can be felt in your aching body, in your rumbling gut, where injustices, like toxins, are dumped, buried, and burned.
 B. This Energy Emergency:
 1. happens at the level of bodies and it's exhausting (see also I.B.2; Section 3.1.I.A.1-9);
 2. gives me a headache--those blaring alarms with nothing to say (see also I.B.1);
 3. shifts . . . perspectives;
 4. makes waves:
 a. heat waves;
 b. airflows and iceflows;
 c. waves of disaster, followed by waves of alternate coolings;
 d. brainwaves and headaches (see also I.B.2);
 e. drainwaves: energy booms and busts, systems breaking down, bodies too;
 f. churn;
 g. wake.

II. The Energy Emergency is *not what you think it is*. Perpetually emergent and emerging, this emergency is both less and more: less the emergency they make it out to be and, at the same time, oh so much more (see also Section 5.1.I).
 A. Less risk, more crisis.
 B. Less crisis, more chronic.
 C. Less chronological, more chronotopically colonial (see also Section 3.1.II.B).
 D. Less accidental, more political.
 E. Less alarming, more exhausting (see also Section 3.1.I.A.1-9):
 1. this is not the same emergency alert that repeats on screens, keeping us company amidst the slow-motion violence of our current energetic depletions;
 2. this emergency is exhausting: emergency exhaustion.
 F. Less shrill, more throb.
 G. Less fact of nature, more act of capital.
 H. Less tragedy, more crime.
 I. Less anthropocentric, more patriarchal and racist.[2]

2. See Kyle Whyte, "Against Crisis Epistemology," in *The Routledge Handbook of Critical Indigenous Studies* (New York: Routledge, 2020).

III. The Energy Emergency is *belated yet incipient*: already past, always to come; too late, what's next;
must fight . . . let's fight (see also Section 3.1.II.B; Section 5.1.IV.B).
 A. This emergency is fuelled by political distractions and responsible actions, then made banal
 by:
 1. the repetition of both conservative mantras--a 'making great again that never was';
 2. progressive visions of 'going back' to some pure, more authentic, pre-emergency time.
 B. This emergency (thanks, WB) is not the exception but the rule (see also II.B).[3]
 C. This emergency cracks time, mixing the promise of peril with the peril of promise.

IV. The Energy Emergency keeps us *alone together*.
 A. This emergency (but also that one and that one and that one) is unequally created,
 disproportionately felt (see also I.D; I.E; II.A-I).
 B. The Energy Emergency is plural. Pleure-all. It raises questions in multitudes,
 for multitudes and for their subalternizations (see also Section 3.1.I.C and II.H).
 1. Whose emergency?
 2. Emergency for which species?
 3. When does emergency become the answer?
 4. When does emergency become the problem?

V. The Energy Emergency is *a problem*--and *an opening*.
 A. The Energy Emergency is not who it says it is. Or not what who says it is says it is (see also
 II.B; III.A.1-2).
 B. In fact, this Emergency can't really be said. It is not a symptom of communication issues or
 the result of a lack of awareness.
 C. Unsayability is a trap door onto saying, or rather saying otherwise: less o fuck, more why
 this? fuck this! what next? . . . enjoy the drop!

VI. Mycelium reminds us that *energy doesn't grow on trees*.
 A. Mycelial energetics are made of:
 1. invisible meshworks;
 2. entangled stretches and strains;
 3. living (and dying) systems of reciprocity and d e c a y ;
 4. sp o r adic r h ythm s;
 5. underworld subversions (see also III, IV).

 B. Mycelium alerts us to how:
 1. interspecies talk is cheap (see also Section 3.1.I.A, E);
 2. thermal conduits offer warmth;
 3. decomposition is growth via degrowth;
 4. sometimes, "carbon capture" is more
 than an empty promise.

3. See Walter Benjamin, "On the Concept of History," https://www.marxists.org/reference/archive/benjamin/1940/history.htm.

2.2
An Anekāntavāda Allegory, or,
Seven Ways of Looking at an Energy Emergency

Nothing but a Chinese communist conspiracy.
Or the eco-socialists.
Or feminists.
Anarchists.
Antifa.
Homosexuals.
Jews.
Muslims.
No, just the Palestinians.
No, no, the Greeks too.
Syrians.
Heathens.
The Liberals.
Quebeckers.
Quakers?
No, Quebeckers.
And Trudeau.

Well, yes, things are
pretty bad
actually really bad,
yeah really, really bad
actually, but, you know
you have only yourself to blame
and, of course, your
neighbours and their
neighbours (you should all
just hold your breath).

but in the meantime
if you could just only be more thrifty
scrimp and save more efficiently
and responsibly--

we have some sparkly
electric cars,
speeding windmills, solar mirrors,
and all the other things
you love

in green
for your bubble
or pod or whatever else
we gave you to
make you feel
special and speaking of
which we have some
very attractive investment opportunities
for you so
you too can feel
like us but
not quite so
evil.

They came
and took everything
and set the rivers on fire
rivers that flow to the seas.

4

From out of a hole in the ground
wiggling, sniffing like a mole, the
shadow
fluttered and floated
and then soared like an angel
from eighty-four tera-joules
to two hundred and forty thousand
tera-joules to 576,000,000 tera-joules
to . . .
and bombs dropping to the South like
eagle shit.

5

Lucky for you
if you can pass
for them
leave
through their gates of gold
leave on the waves of the dead ocean
for the light of dead stars, o
world leaders
of the law of white
lies.

The chasm in the earth runs deep
on one side are the few who take
everything for themselves
and lay the land to waste
with their palaces and citadels
their drive-throughs and their fortresses.
on the other side
where toxins flow with the tide
there and only there
regeneration is held and carried.

You have taken everything from the garden
and from the deeps
in return you send us your poisons and
your terrors.
Even if you
don't know
we know who
you are
you who are fastidious
with all your accounts.

2.3
Energy Mediacy Exercises

Energy mediacy is a pedagogical approach that works to interrogate the metaphors and literacies that have come to define and delimit the energy concept. Energy mediacy sees energy not as content to be learned, but instead as a concept that mediates how energy, and thus its transition, is conceptualized in the first place. Offered as a distinct alternative to the idea of energy literacy, which requires that energy is understood in terms of communicable tracings, measured in quantitative designations, and instrumentalized in terms of more responsible energy use, energy mediacy indicates a being-with energy that involves embodied approaches to grappling with today's emergency exhaustion and the headaches it induces. Here, we have offered one example for exercising energy mediacy, followed by a series of prompts that can be adapted and developed based on the energy emergency at hand/in body.

Energy Mediacy Exercise #1: *Energy Exchange Breathing Exercises*

Set up. Perform this exercise while seated, standing, or lying down and looking up or out into the lower troposphere.

Step 1. Take a deep breath in and hold for about 15 seconds. Read the following as you hold:

Think about the energy exchange taking place in your body. Each inhale brings oxygen into the lungs to be absorbed by the bloodstream, carried through the body, and converted into energy. Waste product CO_2 is carried back to the lungs and expelled in an exhale.

Step 2. Exhale and take a series of deep breaths to prepare for the next step.

Step 3. Take a deep breath in and hold for about 20-30 seconds. Read the following as you hold:

Think about the role your brain is playing in this energy exchange. Your brain controls your breathing rate (how fast or slow you breathe) by sensing your body's need for oxygen and its need to get rid of carbon dioxide. This is called eupnea, an unthinking, automatic energy exchange taking place in your body 20,000 times per day. When you hold your breath, waste CO_2 accumulates inside your body with nowhere to go. Your lungs begin to contract, and your body will seek out more oxygen resources, eventually pulling it from the bloodstream, causing a further buildup of CO_2. Your blood pressure rises and your brain sends emergency signals to breathe back through the bloodstream, causing involuntary spasms of the diaphragm and the muscles between your ribs.

Step 4. Exhale and take a series of deep breaths to prepare for the next step.

Step 5. Breathe in and out at a pace that feels comfortable for you. Read the following as you breathe.

What feels comfortable for some is intolerable for others. This is important to remember when embodying energy exchange in today's milieu of suffocation and forced non-breathing. For while breathing may seem universal, an automatic human process necessary for ongoing energy exchange, it does not come so easy for some. Rather, it is made uneasy by the obstructive apparatuses of power that suck all the air from the room, from the oceans, the land, the troposphere. While some bodies struggle to breathe amidst the heat, smoke, and pollutants that have been fuelled by today's breath-taking scenarios, others are violently dispossessed of their capacity to breathe. As you breathe in and out, take in these matters of life and death: breathe in the legacies of extraction and brutality that have taken so many breaths away, and breathe out the difficult realization that breathing is itself a political act, one that must be fought for and protected in these times of preventable asphyxiation.

Step 6. Exhale deeply and take a series of deep breaths to prepare for the next step. This next step is up to you.

ADDITIONAL PROMPTS FOR EXERCISING ENERGY MEDIACY

Energy Mediacy Exercise #2: *Uneven Distributions*
Using objects found around you, work together to hold on, in very literal ways, to the tensions that arise when you attempt to model the uneven distributions that contribute to today's energy emergencies.

Energy Mediacy Exercise #3: *Subtractive Strategies*
In a small group, brainstorm the dominant metaphors and idioms that come to mind when you think of energy and its potential transitions. Using the mathematical formula $n-1$, where "n" refers to the expansive dimensions of the energy concept and "-1" involves the art of loosening the axiomatic bolts that have overdetermined representations of energy, subtract from the energy metaphors that populate energy discourse today so as to destroy both the problems and solutions proposed by dominant transition grammars.

Energy Mediacy Exercise #4: *Non-Productive Encounters*
Working with peers, research the basic definition of entropy. After just a short time (perhaps 5 or 10 minutes) endeavour to share what you have learned about this enigmatic concept. Using your beginning knowledge (and/or confusion), attune to the non-productive dimensions of energy (and its transitions) where the nons raised by the entropy concept are positioned as sites for struggling against what has been deemed productive in the first place.

2.4
Class Warfare Energetics

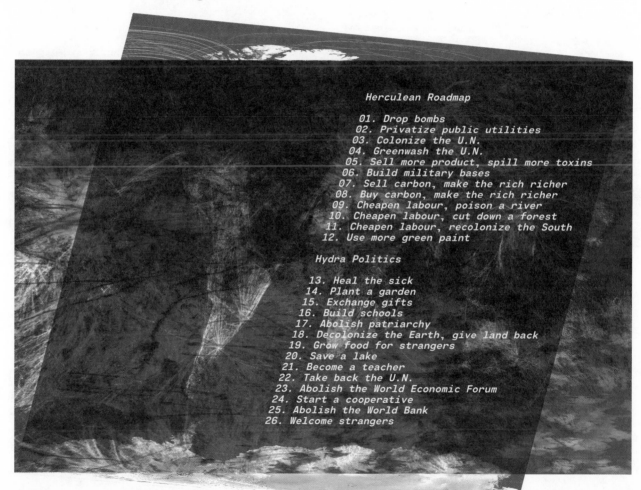

Herculean Roadmap

01. Drop bombs
02. Privatize public utilities
03. Colonize the U.N.
04. Greenwash the U.N.
05. Sell more product, spill more toxins
06. Build military bases
07. Sell carbon, make the rich richer
08. Buy carbon, make the rich richer
09. Cheapen labour, poison a river
10. Cheapen labour, cut down a forest
11. Cheapen labour, recolonize the South
12. Use more green paint

Hydra Politics

13. Heal the sick
14. Plant a garden
15. Exchange gifts
16. Build schools
17. Abolish patriarchy
18. Decolonize the Earth, give land back
19. Grow food for strangers
20. Save a lake
21. Become a teacher
22. Take back the U.N.
23. Abolish the World Economic Forum
24. Start a cooperative
25. Abolish the World Bank
26. Welcome strangers

2.5
Figuring the Energy Impasse

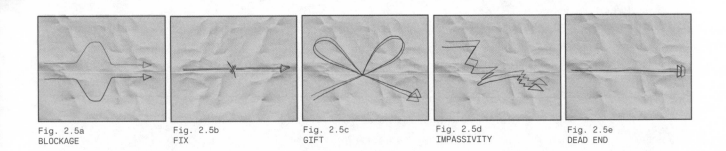

Fig. 2.5a
BLOCKAGE

Fig. 2.5b
FIX

Fig. 2.5c
GIFT

Fig. 2.5d
IMPASSIVITY

Fig. 2.5e
DEAD END

Fig. 2.5f
CUL DE SAC

Fig. 2.5g
MIRE

Fig. 2.5h
EXPRESSION OF
NEGATION

Fig. 2.5i
SITE OF RADICAL
INDETERMINACY

Fig. 2.5j
NO IMPASSE--
ONLY STRUGGLE

2.6
The Fungal-Mentals of Mycelial Energetics

Fig. 1
Heterotrophic Energetic
Breakdown

Mycelium consists of the growing "stem" cells of fungus. Fungi are heterotrophs, which means that they must attain energy from their surroundings, not unlike us humans. Mycelial energetics play an important role in energy cycling within, and between, ecosystems. Mycelium grows by digesting its surroundings and then absorbing the consequence. This decompositional growth eventually leads to the branching and bifurcation of hyphae, and the building of a vast, filamentous mycelial network.

Growth through degrowth: a generative paradox to confound the relentless regime of accumulation that propels the current energy emergency.

Fig. 2
Sporadic Proliferation

The fruiting bodies of mycelium, a.k.a. mushrooms or fungi, do not reproduce by seed nor do they gather energy by photosynthesis like plants do. Instead mushrooms reproduce by means of spores--sporadic proliferation. The germination that takes place through this sporadic energy transfer, in turn, produces a mass of interwoven, single-cell wide structures known as hyphae, which are also collectively known as mycelium.

Irregular, intermittent, surging here, there, elsewhere: energy and its emergencies are never uniform, always disymmetrical in distribution as in consequence. And so the smooth, steady inevitability of today's energy transition logic is a lie and a con. But: the sporadic tendency of struggles for energy justice, hardly diminishing their force, is actually key to their counterpower.

Fig. 4
Energy Cycling

Mycelia, and all of their fungal cousins, can be found in terrestrial, marine, and freshwater environments, making up a diverse community of decomposers that break down and transform organic matter into forms that can energize other decomposers while providing nourishment for various flora. Through breakdown and digestion, mycelia provide access to nutrients that were previously unavailable, locked away. As such, these decompositional bodies, which extend far beyond the cellular walls and discrete identities of individual hyphae, are intimately involved in energy cycling through acts of digestion and decomposition. In freshwater environments, for instance, mycelia and their resulting fungal networks are instrumental in the transfer of energy from riparian forest to aquatic ecosystems (i.e. by decomposing wood and leaf litter that fall into the water). In terrestrial systems, on the other hand, fungal forests transfer energy from above the ground to below it, where it can be recycled back to plants.

As such, the metabolic media of mycelium inspire a critical strategy for decomposing the colonizer's model of the world into other models, including a singularly earthbound critical figure for modelling the systemic features of ecological relationships.

Fig. 3
Decompositional Bodies

Mycelial energetics are fungal-mentally involved in processes of decomposition. Fungi are important, necessary even, to breakdown; they are able to decompose and digest even the toughest of organic materials. Importantly, this digestion takes place not inside but outside of mycelial "bodies": fungi release digestive enzymes that are used to metabolize complex organic compounds into soluble nutrients and then absorb the nutrients into their cells.

Decomp poesis: the pulsing energies from fungal breakdown work to make new worlds possible. Think and feel what we might learn.

Fig. 5
Symbiotic Carbon Storage

Some species of fungi form symbiotic relationships with plants. Mycorrhizal fungi, for instance, are fungi that are associated with plant roots in inextricable ways. The relationship between mycorrhizae and rooting structures is symbiotic because fungi facilitate the transfer of nutrients from the soil into plant roots, and in turn receive carbon from the plant. As a heterotrophic, sporadically proliferating, energy cycling, decompositional body, mycorrhizal fungi actively decompose organic carbon, contributing in important ways to carbon input, loss, and storage. Indeed, mycelium can even act as a "carbon storage facility" by reinvesting carbon into plants in tumultuous times.

Keep it in the fucking ground.

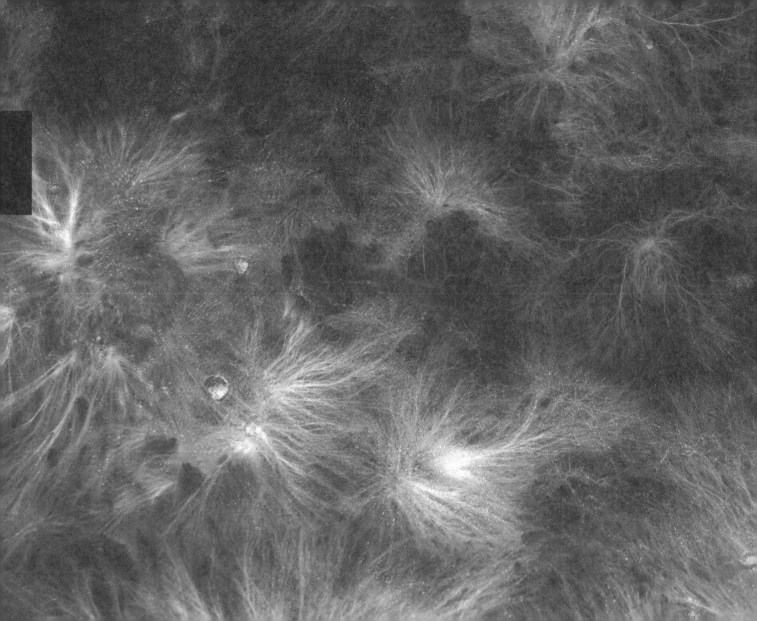

SIGNAL BOOSTS

3.1
Signalling the Energy Emergency

I. Signalling the energy emergency:
 A. *takes energy!* and energy in myriad forms (see also Section 2.1.I.A, D.1-4, II.E.2):
 1. potential;
 2. kinetic;
 3. motive;
 4. emotive;
 5. gestural;
 6. haptic;
 7. rhythmic;
 8. sonorous;
 9. dissonant.
 . . . don't take your pick, because you'll probably need them all at some point or another!
 B. *requires care*:
 1. not just rhetorical care--shouting "I CARE" is not always careful, it's usually strategic;
 2. whereas taking and giving care is work: hard, dangerous, unpleasant, conflicted and therefore rewarding, regenerating, feminized, political, and energetic work (see also I.E.1-5; Section 5.1.IV).
 C. is *always collective*--bound up in (see also II.H; Section 2.1.IV.B.1-4):
 1. regimes of signification;
 2. but also diverse matter and bodies.
 D. is *not always representational*, but is sometimes instead or additionally:
 1. asignifying;
 2. abstract;
 3. decoded;
 4. distorting;
 5. tessellated;
 6. supersaturated;
 7. paramagnetic or diamagnetic;
 8. hyperbolic;
 9. reciprocal, rendering substance and sign co-constitutive;
 10. anisotropic;
 11. noncommunicative, but nevertheless powerful;
 12. virtual.

E. *involves work* (see also Section 5.1.IV.C):
 1. the sweat of semaphore;
 2. the graft of now! again!;
 3. the cunning and courage of imagination;
 4. a willingness to see and unsee, to feel and unfeel;
 5. collaborative, conspiratorial resilience.

II. Mycelium signals energetically, too -- *in more specific terms, mycelium signals:*
 A. against the grain (see also *I.D.1-12; Section 4.1.III.A-L*);
 B. chronotopically: across time across space, **binding s p a c e i n t o t i m e** (see also Section *1.II.6, III*);
 C. proleptically;
 D. using strands and channels (always dense, necessarily decentralized);
 E. using strands and channels (always dense, necessarily decentralized);
 E. mycroremedially;
 F. by confounding (see also Section 5.1.II.A, B):
 1. the usual orders of foreground and background, protagonist and setting;
 2. visions of health and breakdown -- healthy breakdowns;
 3. singularity and plurality;
 4. noun and verb;
 5. carbon's credit;
 G. through joyous subversion (see also I.E.1-5):
 1. interspecies warning signals; but also
 2. subterranean styles of nomadism capable of
 pressurizing
 and boring

 into
 the

 'holey space' of
 becoming;

 7. in chorus, *but not necessarily harmoniously--unified disunity characterizes the symbiotic relationship between hyphae and other rooting structurations* (see also I.C; Section *2.1.IV*);
 8. in darkness (or so it seems).

3.2
Sound the Alarm:
Four Contemporary Frequencies of Emergency Communication

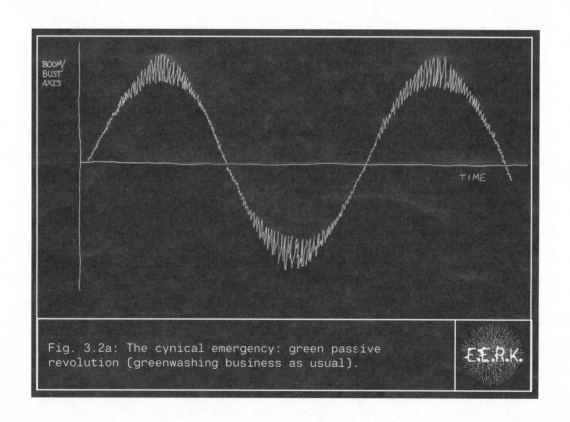

Fig. 3.2a: The cynical emergency: green passive revolution (greenwashing business as usual).

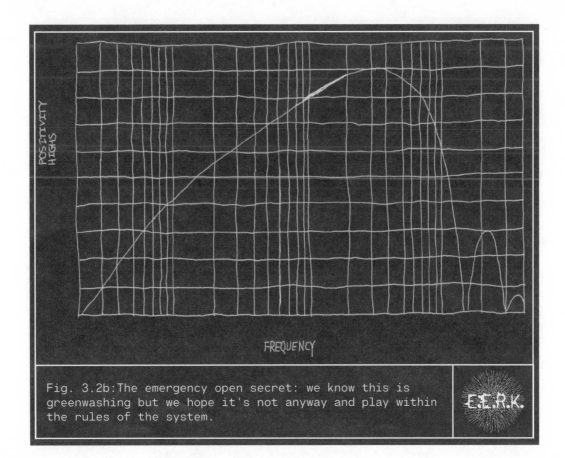

Fig. 3.2b:The emergency open secret: we know this is greenwashing but we hope it's not anyway and play within the rules of the system.

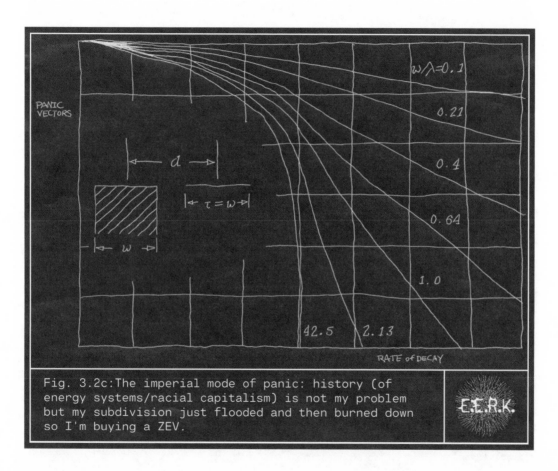

Fig. 3.2c:The imperial mode of panic: history (of
energy systems/racial capitalism) is not my problem
but my subdivision just flooded and then burned down
so I'm buying a ZEV.

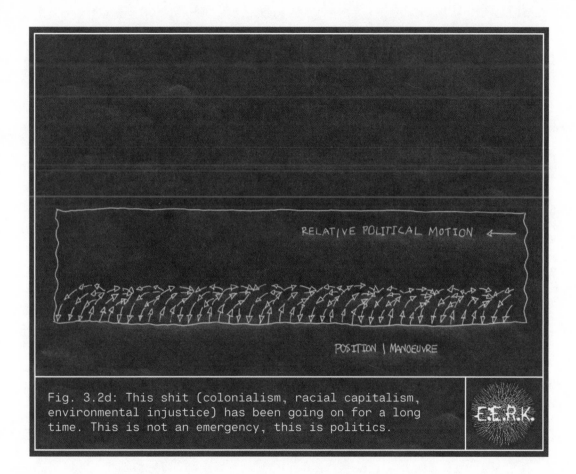

RELATIVE POLITICAL MOTION ←

POSITION | MANOEUVRE

Fig. 3.2d: This shit (colonialism, racial capitalism, environmental injustice) has been going on for a long time. This is not an emergency, this is politics.

E.E.R.K.

3.3
SOS Signals

Use the SOS signals below to communicate your energy emergency. In the space you share and the time you spend with this manual, practice some of these signals with those around you.

Send these signals (using short and long screams) when:		
Your boss claims, time and time again, that you must do more with less.	WAIT	● — ● ● ●
Rich people poison your drinking water to buy their new electric car.	SAY AGAIN	● ● ● — ● ●
Officials conflate economic "health" with social "health," no matter the cost.	ERROR	● ● ● ● ● ● ● ●
Kleptocrats invoke "public trust" to justify cuts to public services while stroking their donors.	!	— ● — ● — —
Industry grabs your land to offset their carbon emissions.	WRONG	— — ● ● ● ● — ● ● — ●
Mega-malls and mega-churches stay open while pandemic rages.	INVITATION TO TRANSMIT	— ● —
You run out of gas.	END OF WORK	● ● ● — ● —
You run out of will.	UNDERSTOOD	● ● ● — ●
You run out of time.	CLOSING DOWN	— ● — ● ● — ● ●

3.4
Emergency Auto Responses

Thanks to the calamitous alchemy of cloud computing and the 24/7 drumbeat of communicative capitalism, the inbox is energy emergency writ small:

- always on, never off
- always there, never there
- impossible to live with, impossible to live without
- magnetic: teasing yet forcing action at a distance
- belated, obdurate, perpetual
- strangely attractive
- endlessly enervating and exhausting

How best to cope with the overwhelming energetic challenges posed by the inbox, when delinking is not really viable and the automated vacation message raises too many eyebrows? Try any of the following Emergency Auto Responses (EARs), designed by the E.E.R.K. Team to minimize energetic expenditure while generating maximum enjoyment. The EARs collection features two styles:

1/ the Inbox Inhibitor, which disrupts email circuitry for temporary respite; and
2/ the Decomp, which solves every inbox problem once and for all.

1/ Inbox Inhibitor

This type of EAR comes in five varieties, as outlined in the following pages. As Elizabeth Gurley Flynn never said but might well have agreed, a very small shoe in the gears is still a shoe in the gears[4]

[Optional accompaniment: Tape 1: Patches, Side A, any track]

1.A The Prefab:
Often, the simplest solution is the simplest solution: predictive reply from the computational robot. When in doubt, choose the vaguest or most non-committal option.

4. See Elizabeth Gurley Flynn, *Sabotage: The Conscious Withdrawal of the Workers' Industrial Efficiency* (Chicago: IWW Publishing Bureau, 1917), https://www.marxists.org/subject/women/authors/flynn/1917/sabotage.htm.

1.B The Classic:
Speaks for itself.

1.C Bartleby, the Teenager:
Emoji power!

1.D Bartleby, the Polyglot:

Amplifies the babble of email with online translation in order to confound your inbox's imperatives.

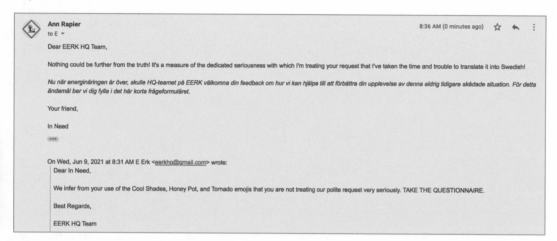

Ann Rapier
to E ▾ 8:36 AM (0 minutes ago) ☆ ↩ ⋮

Dear EERK HQ Team,

Nothing could be further from the truth! It's a measure of the dedicated seriousness with which I'm treating your request that I've taken the time and trouble to translate it into Swedish!

Nu när energinäringen är över, skulle HQ-teamet på EERK välkomna din feedback om hur vi kan hjälpa till att förbättra din upplevelse av denna aldrig tidigare skådade situation. För detta ändamål ber vi dig fylla i det här korta frågeformuläret.

Your friend,

In Need

•••

On Wed, Jun 9, 2021 at 8:31 AM E Erk <eerkhq@gmail.com> wrote:
Dear In Need,

We infer from your use of the Cool Shades, Honey Pot, and Tornado emojis that you are not treating our polite request very seriously. TAKE THE QUESTIONNAIRE.

Best Regards,

EERK HQ Team

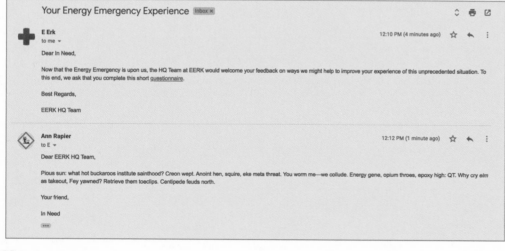

Your Energy Emergency Experience Inbox × ↕ 🖨 ⎘

E Erk
to me ▾ 12:10 PM (4 minutes ago) ☆ ↩ ⋮

Dear In Need,

Now that the Energy Emergency is upon us, the HQ Team at EERK would welcome your feedback on ways we might help to improve your experience of this unprecedented situation. To this end, we ask that you complete this short questionnaire.

Best Regards,

EERK HQ Team

Ann Rapier
to E ▾ 12:12 PM (1 minute ago) ☆ ↩ ⋮

Dear EERK HQ Team,

Pious sun: what hot buckaroos institute sainthood? Creon wept. Anoint hen, squire, eke meta threat. You worm me—we collude. Energy gene, opium throes, epoxy high: QT. Why cry *elm* as takeout, Fey yawned? Retrieve them toeclips. Centipede feuds north.

Your friend,

In Need

•••

1.E Tender Buttons:

Turns inbox dross into outbox gold via anagrammatical surgings.

36

2/ Decomp

Taking its cue from mycelial hyphae, this type of EAR works sporadically to decompose, decarbonize, and mycroremediate email. Once activated, the Decomp will comprehensively repair any and every energy emergency caused by your inbox. Follow detailed instructions below. NB: advanced coding skills necessary for optimal results.

[Required accompaniment: Tape 2: Fixes, Side B, Track 01]

3.5
Tuning In to Mycorrhizal Networks

This exercise offers a slow approach to deliberate species recalibration; a sort of *tuning in* to the processes of interspecies breakdown and the decompositional communications found within mycelial networks. Attuning to what mycology can teach us about "network theory," which itself must always be a process highly aware of the limits of all-too-human intellectual and sensorial tools, not to mention the historical and systemic forms of speciesism that have been necessitated by the ongoing exploitation of so-called "natural resources," this exercise invites humble experiments in the art of *multi-species convivial conversation*. As such, this exercise asks you to *listen deeply*, directing attention, for instance, underground, but also to *deliberately focus, redirect, even transition your energy* to the inter-species breakdowns happening all round, for better or worse.

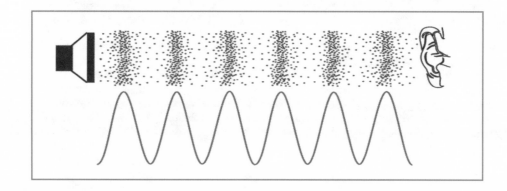

DIRECTIONS

1. Choose one of the *generative focus points* below.

2. Adopt a comfortable position, firmly connected to the ground.

3. Begin to "listen," "visualize," or "feel" (or all three).

4. Using the generative focus points and prompts offered below, tune in to the entanglement of interconnected strands. Allow your mind to follow the meanderings of one strand, before following some of the adjoining branches; keep the focus/prompt in the forefront of your wanderings. Ask yourself: What are you hearing/seeing/feeling?

 Note: Free fall away from the strands can happen; bring your mind and (inner) ears/eyes back, gently, to rejoin one of the awaiting hyphae. This is convivial travel. It is slow. Regenerative. Reverberating. Where do these strands take you? If it is a quiet journey; one to "nowhere," to a (near) silent, seemingly uninhabited space: rejoice. If it is a place of thrumming, pulsating energy and interspecies messages, take note of this, too. The journey is without end; meandering; unfolding; returning. Going everywhere/nowhere.

 Consider the mycelial "listening" you have done. What have you sensed? End your mycelial journey of deep listening by acknowledging and giving gratitude to the path that never ends. Consider sharing mycelial insights/experiences with someone/something close to you, giving the gift of further mycelial conversation.

GENERATIVE FOCUS POINTS

You might tune in to:

1. *Mycelial Conversations:* Tune in to communications across species; space; time. Acting as a conduit of nourishment and information across these chronotopical assemblages, listen against the grain.

2. *Mycorrhizal Networks:* See point 1, but focus this time on confounding usual orders of foreground and background, protagonist and setting, the one and the many.

3. *Alerts:* Sound the alarm, alerting neighbours, near and far, to paths of danger but also paths of conspiratorial opportunity (see also Section 3:2: Sound the Alarm; Section 3.3: SOS Signals).

4. *Embracements:* Attune to those neglected things that, when re-encountered, necessitate a whole new understanding of care-giving practices; look out for growing sounds, amplitudinal ups and downs, and new feeding grounds (a.k.a. opportunities for decompositional embrace).

5. *Cycles:* Cycles of de/composition, re/generation, and other hyphae-nated encounters.

6. Create your own generative focus point or digest and recompose one offered by someone close by.

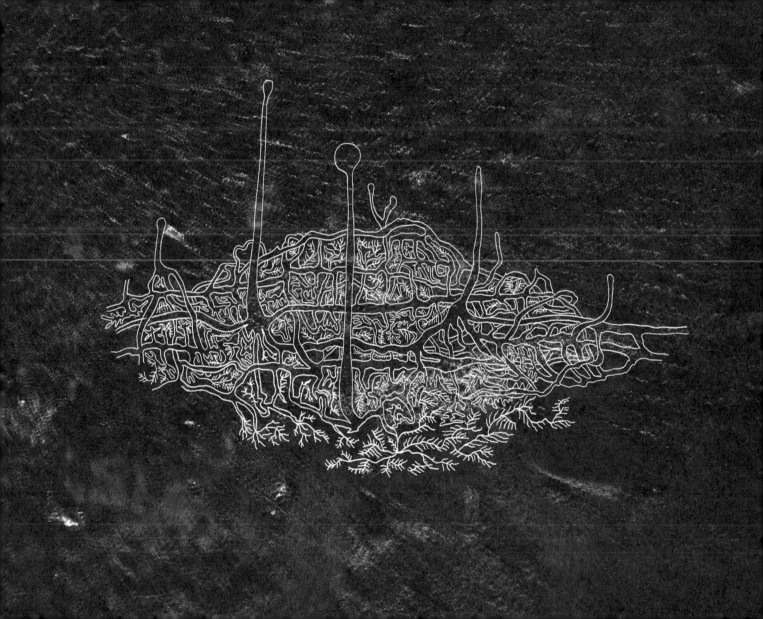

NON-STANDARD OPERATING PROCEDURES (NSOPs)

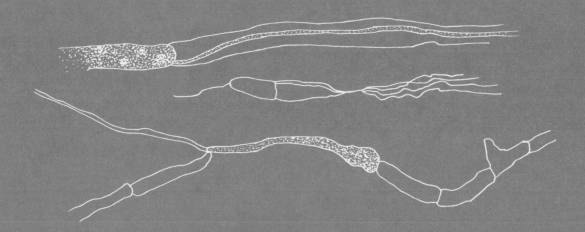

4

4.1
A Note on NSOPs: Ops, Stops, and Voids

In this section, you will be introduced to some non-standard operating procedures for navigating your energy emergency.

I. These *step-by-step-by-stop-by-what? instructions* will:
 A. help you to carry out non-routine operations that ensure:
 1. inefficiency;
 2. unknown outputs; and
 3. a diversity of performances based on the contingent relations of your energy context;
 B. proliferate misuse value against and athwart customary paradigms and habituated methods of perpetual accumulation and exchange;
 C. necessitate various modes of de/composition: composing so as to decompose, organizing to disorganize, together (see also Section 2.1.IV; Section 3.1.I.C and II.H).

II. Through these non-standard (mis)directions you will be provided with prompts for *disorganizing the industry standards* that have failed to comply with (while serving to cause) the emergency situation being felt all around.

III. The operations (Ops) offered here are *formulaically complex* (see also Section 3.1.I.D.1-12 and II.A; Section 5.1.V). Not unlike monokaryotic mycelium, which, when joined with dikaryotic mycelium, may (or may not) form fruiting bodies, these non-standard Ops are contingent on the energetic relations to which they are applied and/or re-situated. Akin to mycelia networks and their branching hyphae, these NSOPs involve the proliferation of *strange operations*, including, but not limited to:
 A. stops and slowdowns;
 B. turnarounds;
 C. backward, wayward, forward inversions and diversions;
 D. comings and goings;
 E. growovers, growarounds (but also workovers, workarounds);
 F. enmeshments, nourishments, replenishments;
 G. (up)rootings: putting downs, taking ups;
 H. de/compositions;
 I. virtual sabots in the gears and kindred hacks;
 J. growing tentacles; and then growing some more;
 K. backstops, stopovers, nonstops; and
 L. generative degenerations.

IV. Although we have offered specific examples, we *encourage the creation of further Ops, but also Stops and Voids*, that emerge from the substrates through which you find yourself de/composing.

 A. Stops, after all, make things happen too. The friction stopping an object in motion converts kinetic energy into thermal energy: work into heat. Non-standard operating procedures work toward stopping, which sometimes involves more heat than work, and sometimes involves cessation, full stop, and sometimes involves actively working at not working well
 B. Stopping an object in motion takes more energy than not, so the scientific experts say.
 C. Non-standard operating procedures work toward stopping,

 which sometimes involves cessation,

full stop,

and sometimes involves

a c t i v e l y

working at not working well (see also Section 3.1.E.1-5). [5]

5. See Sarah Sharma, "A Manifesto for the Broken Machine," *Camera Obscura 104* 35, no. 2 (2020).

4.2
Nuclear Waste Safe Storage Protocol
(Country Club Conversion Edition)

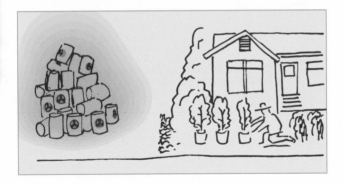

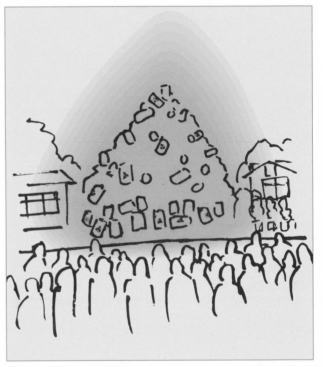

DIY Nuclear Waste Safe Storage End User Agreement

This DIY Nuclear Waste Safe Storage End User Agreement (the "Agreement") is between you and the entity that currently happens to own the Software that you are accessing or using here. This Agreement governs your initial access to this Software as well as to any future thoughts, wishes, misgivings, or rashes referencing this Software. The term "Software" includes its Documentation, Meaning, Concept, or Application unless otherwise specified. In which case it excludes the term "Software" inclusively defined in this Agreement or you, the end user, depending on whether the effective date of this Agreement precedes or succeeds any officially declared energy emergency, nuclear winter, or extinction event, whichever comes earlier. The term "you" in this Agreement refers to you, not me, unless you are agreeing to this Agreement on my behalf, in which case "you" in this Agreement no longer refers to "you" exclusively. If you are agreeing to this Agreement on behalf of your employer, company, government, neighbour, income group, religion, community, ethnicity, spouse, species, or sponsor, then "you" means your entity, entirety, and next of kin and you are binding your entity, you, and your descendants eternally to this Agreement.

1.Scope of the Agreement: This Software is not intended for and should not be used by anyone under the age of 21 or over the age of 18.
2.Restrictions: Except as otherwise expressly permitted in this Agreement, you will not a) reproduce, modify, adapt, create derivatives, b) rent, lease, distribute, sell, transfer, c) reverse engineer, disassemble, decompile, d) translate, alter, remove, extract, source, recode, eat, sleep, or breathe while accessing or using this Software.
3.Survival: All restrictions defined in this Agreement survive either your termination or that of the Agreement or both.
4.Limitations of Liability: By agreeing to this Agreement, you and your entity agree that E.E.R.K. accepts no liability for any loss of use, inaccuracies or loss of data, loss of profits, loss of life, limb, or self-esteem incurred from or alleged to incur from the use of this Software.

By clicking on the "I agree" that is presented to you at the time of your Order, or by using or accessing the Software, you indicate your assent to be bound by this Agreement. If you do not agree to this Agreement, do not use or access the Software and run for the hills.

I AGREE

1. SELECT CURRENT WASTE STORAGE
2. DRAG AND DROP IN TARGET COUNTRY CLUB

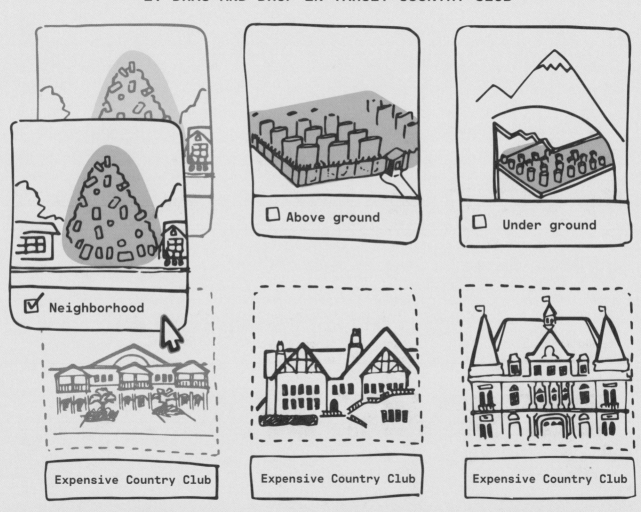

4.3
How to Safely Operate Your Kwik-Set Oligarch Extractor Pro

Step 1:
In a well-ventilated and clean workspace, spread out a waterproof tarp at least 5m x 5m but no more than 100m x 100m, making sure there are no creases, and secure the corners with bricks.

Step 2:
Arrange highly qualified personnel, critical data sets, or other operational assets left over from budget cuts to the target public utility or agency in an evenly spaced 4m x 4m matrix.

Step 3:
Use a toothbrush and a solution of equal parts vinegar and water to remove any signs of stress or wear. Dry with a soft, clean cloth.

Step 4:
Place a straight back wooden chair behind each exposed asset.

Step 5:
Using an unopened box of chocolates or a suitcase of cash, position a jurisdictionally relevant public official on each chair.

Step 6:
Set out and light candles to form a five-point star enclosing the asset portfolio.

Step 7:
Position and set the oligarch trap at each asset position by moving mechanism A counter-clockwise until the official head aligns with the mechanism teeth.

> *CAUTION: REMOVE JEWELRY, WATCHES, LOOSE CLOTHING BEFORE OPERATING MECHANISM. DO NOT ALLOW FINGERS TO COME INTO CONTACT WITH THE BLADE.*

Step 8:
Dim the lights and wait overnight.

Step 9:
After a minimum of eight hours, use lever B to dislodge oligarchs from hooks C. Wearing rubber gloves, use the legislation enclosed in the Oligarch Extraction Kit to indict and remand oligarch collection to your local labour recruitment office.

SUPPLY LIST:

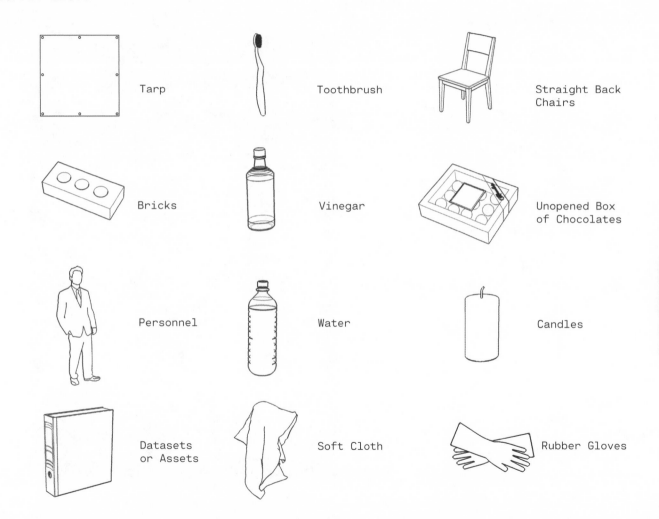

Tarp

Toothbrush

Straight Back
Chairs

Bricks

Vinegar

Unopened Box
of Chocolates

Personnel

Water

Candles

Datasets
or Assets

Soft Cloth

Rubber Gloves

4.4
Blackout Checklist

A cheat sheet / crib notes for the
future imperfect.

no guns--no exceptions

4.5
Ecological Debt Recovery Procedure

Step 1
Unplug global economy simulator, let cool to solar surface temperature.

Step 2
Position goggles for comfort, pull straps tight. Put on oven mitts.

Step 3
Using a Phillips No. 8 screwdriver, loosen screws on economic black box casing, set aside carefully. Use chisel provided to dislodge any Wall Street funded economist encrustations. Facing away from the simulator, remove lid.

Step 4
Take pies out of the oven and set on picnic table to collect community youth.

Step 5
Position community youth in alignment with block and tackle. Tighten safety helmets. Hoist social metabolism vortex accelerator out of the simulator and feed to mycelium bath.

Step 6
Reset productivity regulator to full employment.

Step 7
Check dice for tampering by bankers. Discard if necessary. Roll dice.

Step 8
Use the lower number on the dice throw to set the ratio of basic minimum income to world maximum income.

Step 9
Slide work time regulator back to the higher number in dice throw.

Step 10
Expropriate the expropriators.

Step 11
Install Limit Donut. Reverse the polarity of the blue and red wires to reverse simulator flows.

Step 12
Replace lid. Hand tighten all screws.

4.6
Seven Simple Steps for Mycelial Networking

1 *Mycelial networking is about multi-scalar relations.* So branch out! Dilate the coordinates of your communities-to-come, from the micro to the macro and back again. Don't forget: you were made to rock vast filamental networks!

2 *Be the one, but also the many, to decompose.* You are a nourishment provider. Heterotrophic and sporadic, you know how to digest your surroundings and absorb the consequences. Now help others learn to do likewise

3 *Be quiet.* No need to get loud to get noticed. Remember, silence is golden, fungally-speaking. Press play on the shhhh factor to attain max energy from your surroundings.

4 *Anticipate dis/connection.* Breakdown? Break out! Time for symbiotic relations among and across all the fruiting bodies!

5 *Expect unanticipated diversions.* Terrestrial, marine, freshwater settings: you've got contacts everywhere. Which is amazing! But also . . . exhausting. So don't worry about getting distracted--focus is very overrated. Besides, what seems like diversion today can often become reinvestment tomorrow!

6 *Reach out, and then back in, and out and in and out and in* You munch the toughest from inside out for breakfast. So don't be shy: work that diverse heterotrophic community! The energy you cycle will only make you stronger.

7 *Always energize.* Step first: germinate. Step next: proliferate. Now repeat

RITUAL MAINTENANCE

5

5.1
Un-Doing the Energy Emergency

In this final section, the E.E.R.K. team has provided techniques for and practices of *ritual maintenance* aimed at un-doing today's and tomorrow's energy emergencies.

I. These maintenance protocols have been designed based on the recognition that *un-doing the energy emergency* is:
 A. probably impossible, but no less necessary for that impossibility--or:
 1. an impossible necessity;
 2. a necessary impossibility;
 B. more cut than unravelling--but maybe less, too (see also Section 2.1.II).

II. Un-doing the Energy Emergency requires *ritual maintenance*.
 A. While rituals may typically be defined by formalism, tradition, and invariance, the ritual maintenance necessitated by today's energy emergency is one focused on sustaining encounters with these very things--formalism, tradition, invariance--so as to un-do and decompose the rationality that made them possible, thinkable, in the first place (see also Section 3.1.II.1-5).
 B. Ritual maintenance involves, in the first instance, short-circuiting the blaring alarms that have drowned out everything else, leaving us in a communicative nightmare, and in the second instance, mutating and regenerating the connective tissues that have been severed and overcoded by the pragmatisms installed by today's emergency leaders.

III. Key to ritual maintenance is the practice of *speculation* (see also IV.D). The speculative mode offered here is:
 A. a necessary conjecture--in an atmosphere of incomplete information;
 B. a failure to congeal;
 C. an ongoing commitment to difference despite the call to will the same;
 D. a re-tuning toward practices of incipient thought, or that which has yet to be made thought.

DISCLAIMER: Speculation is not an inherently emancipatory practice. As today's speculative financial operations clearly demonstrate, speculation is not always liberatory nor can it claim guarantees to offering lines of flight away from calcified power relations and repressive organizations of desire. Where energy futures and their financial derivatives, for instance, work to produce the reality they predict, one defined by calculated risks and the imperative for infinite capital accumulation, speculation operates to divert energies into the speculative casino of finance in the hopes of capital appreciation. And so, where the future is increasingly becoming the new terrain of financial speculation, speculation itself must be approached with non-standard operations of repair.

IV. Likewise key to ritual maintenance is the *practice of care* (see also Section 3.1.I.B).

 A. Taking care in and for your Energy Emergency is *not a straightforward process*. Taking care is, in fact, not really about taking, but about giving. This language of giving and taking is itself not quite what happens in caring relationships.

 1. Care does not get doled out in a transactional manner, moving from A to B--"there's only so much care to go around."

 2. Like mycelium, care is a mass noun, it names a thing that cannot be counted, a thing that eludes transactional logic and discrete exchange.

 B. Taking care has a funny relationship with *tense and time* (see also Section 2.1.III). Taking care is, at once:

 1. a prospective process (keep from harm), and;

 2. a retrospective process (look after) . . .

 C. Taking care is *hard work* (see also Section 3.1.I.E). Taking care is:

 1. constant;

 2. perpetual;

 3. undervalued;

 4. gendered and racialized;

 5. the work behind the work;

 6. essential to the work of social reproduction.

 D. Taking care involves a situated and committed form of *speculative sensitivity* (see also III).[6] Taking care:

 1. entails a commitment to turning one's attention to and assembling neglected things--that which has been obscured, most often purposefully;

 2. is what sensitizes us to those relations--of suffering, of exclusion--that are often invisible but also inescapably implicated in that which has been deemed a matter of concern.

 E. Taking care means *resisting uniform applications* and the lure of commodified care (which really just says "I could care less" but it says it by saying it's caring more: "We care" has become their mantra, but it lacks commitment [and funding]). As such, taking care:

 1. is not a haphazard activity;

 2. is not something that can be made formulaic;

 3. eschews easy categorization: "a way of caring over here could kill over there";[7]

 4. means asking in each instance, over and over and over, how to care now;

 5. requires mourning to make refuges for the arrival of strangers.

6. See Maria Puig de la Bellacasa, *Matters of Care: Speculative Ethics in More Than Human Worlds* (Minneapolis: University of Minnesota Press, 2017).

7. See Maria Puig de la Bellacasa, "Matters of Care in Technoscience: Assembling Neglected Things," *Social Studies of Science* 41, no. 1 (February 2011): 100.

V. Mycelium offers one site for speculative elaboration (see also Section 4.1.III). Mycelium speculates otherwise, care-fully and care-lessly, by for instance:

 A. opting for abnormal meandering and/or attenuated (hyphae-nated) responses that reorient direction of growth in response to environmental conditions to:
 1. route and reroute towards hydration;
 2. make pathways for survival
 through decomposition;
 3. navigate around and through (seemingly) impenetrable objects;

 B. engaging morphogenic programs or fusions that spur:
 1. unexpected connections and alliances (see also D.3.C);
 2. openings and closings. ///////

 C. nourishing saprophytic grounds for future footsteps via:
 1. strange waste treatment protocols;
 2. the remaking of solid ground, preventing buildup of too much matter while tapping into previously unavailable energies;

 D. reminding us that substratum maneuvers:
 1. grow from the bottom up,
 but also down,
 between, and around;
 2. hold power in their numbers, which ebb and flow based on the numerous contingencies of any given situation;

 3. take care, but also give care, via:
 a. multispecies, reciprocal communication (i.e. to create fertile soils);
 b. resistance and resilience (i.e. trees become more drought- and disease-resistant with the aid of mycelium);
 c. extensions of reach (i.e. to tap into nutrients);
 d. expansion of surface area for others to thrive, but also decompose (i.e. other plants, such as trees);
 e. waste management (i.e. instances of waste are, in fact, necessary for mycelial energy cycling [see also C.1]).

5.2
Earthcare Regeneration Ritual

Earthcare Holding Ritual

In case of any energy emergency or any emergency energy,
perform this Earth holding ritual
with any and all externalities you find yourself with.

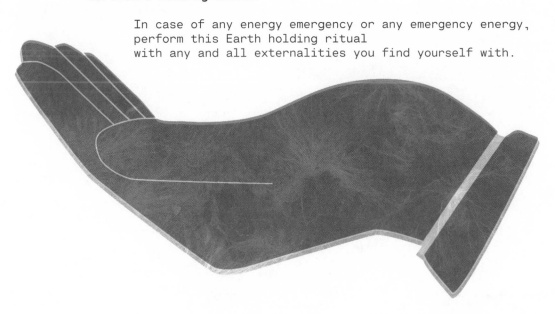

5.2.1
EMERGENCY RESPONSE SYSTEMS

Gather at the nearest muster station (do not run). Complete the roll call. Form survivors into rescue teams and regularly study and practice the following:

Understanding Your Energy System through Time

Use the red cables (sold separately) to connect the universal
hunger innovator
to the universal
defecation manifold.

Green Growth Readiness Roadmap

Sit together uncomfortably
light a candle
link arms or legs
dig a deep hole
suck out the bitumen
run, crawl, or roll in all directions
lie down and
fill the hole with carbon
cover yourself with a blanket.

Toxic Masculinity Profiling Tool

Complete the form below:

age:
income bracket:
shoe size:
make, model, and year:
relationship:

Push pins firmly through target with care.
Compare results in relevant subcommittee.

5.2.2
OFFSET DERIVATIVES

Divide into unequal agile response teams, compete for the successful completion of the following challenges while barking ferociously at your opponents:

**In Case of Environmental Racism,
Green Gentrification, or Fire**

Organize a community e-waste drive
collect old batteries, devices, appliances
dump collected material on yourselves and
build a fort with it all
huddle inside in a circle
reach into the pocket of the person beside you
take their wallet
include in transfer of public assets to private
numbered accounts.

**In Case of Flooding, Land Grabbing, or
Livelihood Loss**

Cup your hands in front of your mouth
tilt your head forward
take a deep breath, hold for 30 seconds
blow forcefully and steadily into your hands,
while wriggling your ears and toes
simultaneously
trade your carbon for 3 credits on the NYSE for
your next flight to the sun.

In Case of Enslavement

Everyone assembles with their hands tied behind
their backs
(tie your own before assisting others)
lock yourselves into small dark closets provided
blame yourself for everything
everything.
Use anything
anything
you can think of
to break each other out
to break each other out
anything
is stronger now than everything.

5.2.3
REGENERATION GUIDES

Traverse as great distances as possible and read out loud to each other:

Work Time Reduction Guide

Breathe in deeply
discuss the meaning of life with a stranger
flex a muscle
together make something your ally needs
sing one song with your neighbours for every hour
of work you performed this week
the more you sing together the more work
becomes the length of time a dragonfly drinks from
a pond
receive the rain with your face
don't let the racists win.

Make Your Day Feminist Guide

Form a party
throw a party
throw your laughter to the cauldron Earth

Energy Fabric Mending Guide

Come together in a circle
carefully undulate
to call the lightning to the lake

Holding the wind by the nose
circulate what lifts you with the swell
keep one fish less than you need
and let the grass grow

let your work be
food for each other
stay in a circle
eat what the Earth eats.

Mutual Aid Guide

As quietly as you can, feel your weight ride
the spin of the earth
 toward the sun
 set

toward the sun
rise
there is
no other way to make
a revolution
comrade
hydra

hold your body however you can
give your hand or
whatever you can
give to someone who needs
it and plug
in all the moving parts
moving the animal body toward any
one and every
one who
will help it
learn how to live
in the seas of ash and
the cities of fire

together
make a
sound
and then
another
and another and
another however
you can
as loud
as
you
can

5.3
Care Instructions

These *care instructions* share with their everyday counterparts an idiomatic tendency toward directive language, but the energetic impulse on offer seems to want to deviate. Where ordinarily such instructions showcase and protect the indifferent differences driving commodity fetishism--brand loyalty, handle with care, avoid misuse, not legally liable--the E.E.R.K. team takes care to instruct in hopes that care might become something other than mere transaction:

irreducible to the economics of the trickle-down;
irrepressible as a substratum maneuver, a decomp poesis, a blooming of spores.

In this spirit, users are urged to do more than simply mind these instructions. Deploy them as transfers or stickers or stencils or tags or tats or marginalia or palimpsests or skylight signals or whatever--just so long as they activate and proliferate their meanings-to-come out into your worlds! And if you tear your jeans in the process, you tear your jeans in the process. As the fortune says:

Never wear your best pants when you go to fight for freedom.
Lucky Numbers: 5 12 25

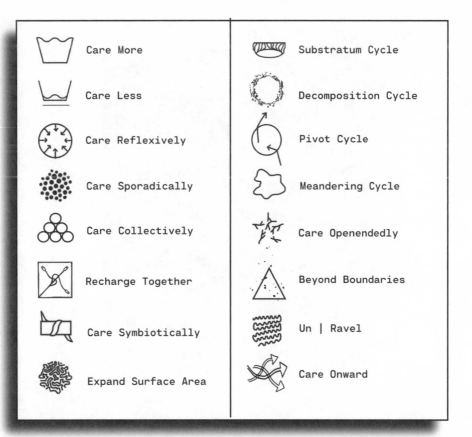

Care More

Care Less

Care Reflexively

Care Sporadically

Care Collectively

Recharge Together

Care Symbiotically

Expand Surface Area

Substratum Cycle

Decomposition Cycle

Pivot Cycle

Meandering Cycle

Care Openendedly

Beyond Boundaries

Un | Ravel

Care Onward

5.4
Pluriversal Journal Writing

Remember you are water.
Of course you leave salt
trails. Of course you are
crying.
Flow.[8]

Take care of ourselves and
each other, spend time with
loved ones, take breaks when
necessary and enjoy each
moment on this lovely green and
blue planet.[9]

8. See adrienne maree brown, *Emergent Strategy: Shaping Change, Changing Worlds* (Chico, CA: AK Press, 2017).
9. See Tooker Gomberg, http://greenspiration.org/tooker/bio-tooker-gomberg/.

Pluriversal Journal Writing is a form of thinking on paper; of communicating--with yourself (and your own species), and if you so choose, with others (and other species). Pluriversal Journal Writing focuses its attention on regeneration and restoration. Grounded in the work of a number of influential individuals and creative networks--including, specifically, the anti-capitalist work of activist-writer Emma Lui and performance artist Tricia Hersey[10] --journaling, like resting, is conceived as a generative way of honouring ourselves, of attending to trauma--both past and present--and the needs and cycles of our bodies, which are intimately entwined with the bodies, lands, and ecosystems around us. In addition to being a safe space (to write, store, and potentially share thoughts and experiences), the journal also--and importantly--functions as what Brian Arao and Kristi Clemens describe as a "brave space."[11] Risks may be taken here; the "unspeakable" may be represented and recorded, vulnerabilities explored. As such, this approach to journaling requires various forms of care--care of and for oneself, and by extension, care of and for others.

The journal can function in many ways. Each person will know what is right for their own personal research/trauma journal. It will assist in creative research. It can also become part of a personal or joint archive--comforting in its physical existence; in its artefactuality; a location in which the most creative or the most painful of thoughts and memories are safely and lovingly stored; it can be left alone to be this safe container; or, on the other hand, it may be returned to, consulted, learned from; perhaps even shared.

Consider, though, another option: burying the journal; perhaps deep in the woods--it becomes a forest ritual; a creative performance; returning the paper and markings that are the journal to the soil; it is the planting of the Pluriversal Journal. The journal, in this way, extends its role in becoming an anti-extractivist, multi-species project. Engaging in "deep collaboration," the profound, slow, and long durational object-microbial intercourse becomes compostual, fecund, generative. Moving from a linear, resource-driven, and production-based form of knowing and creating to one that is circular, non-exploitative, and relational. The journal becomes a gift to the pluriverse, literally contributing to a multi-species environment of a rich and enabling humus.

10. See Emma Lui, "Why Healing Activist Burnout Is Essential to Dismantling Capitalism," https://rabble.ca/news/2020/10/why-healing-activist-burnout-essential-dismantling-capitalism; Tricia Hersy, The Nap Ministry, https://thenapministry.wordpress.com/.
11. See Brian Arao and Kristi Clemens, "From Safe Spaces to Brave Spaces: A New Way to Frame Dialogue Around Diversity and Social Justice," *The Art of Effective Facilitation* (Sterling, VA: Stylus, 2013).

Use the prompts below to inspire your Pluriversal Journal Writing. You can choose to document your thoughts through your own materials, or you can add a short entry to this manual, which will be carried forward to those who reference its materials in the future. In addition to written text, the "writing" prompted here can also include drawings, found objects, and any other marks that help with this care-ful, restful, paperly thinking.

PLURIVERSAL PROMPTS

I. Braving Grief: In whatever form of writing and/or mark-making you choose, venture to take some risk, record something "unspeakable," and/or explore some vulnerability, at once safely and bravely.

II. Body Talk: Find a quiet place and listen closely to the rhythms of your body, but also those bodies flowing around and through you. Record this body talk using a form of writing that moves you.

III. Resting Resistance: Stop. Contemplate and/or explore through writing and/or mark-making what resting, as a form of resistance, might mean and might do for you.[12]

IV. Sharing, Archiving, Composting: Discover where your journaling might want to go: held and stored as a personal comfort; shared with others in a joint archive; given to the world by planting in a field or burying in a wood; somewhere else again.

12. See Lui, "Why Healing Activist Burnout Is Essential."

5.5
Void Spells

/////

Supporting nuclear reactors:
A memorandum,
A feasibility,
A potential timeline.

Non-emitting energy sources committed to
The existing agreement.
Help!

Keep any future hopes
To provide power.
Diversify, create, reduce.
Small supply?
Need steam committed to
Energy
That could significantly cut Canadian oilsands
producers.

supporting

nuclear reactors

a memorandum

d a feasibility

a potential timeline

non-emitting energy sources

committed

to

the existing agreement.

help

keep

any future

hopes

to provide power

diversify

create

reduce

small

supply

need steam

committed to

energy,"

significantly cut

Canadian oilsands producers.[13]

13. The Canadian Press, "Alta., Ont., Sask. and N.B. Sign Agreement to Explore Small Nuclear Reactors (Five Things to Know About Canada's Proposed Small Modular Nuclear Reactors)," *CBC News*, April 14, 2021, https://www.cbc.ca/news/canada/edmonton/nuclear-reactors-clean-energy-option-1.5986796.

/////

Sphinx was the last, and insufficient.
Overburden entered.
"Into the pit, stakeholder group!
Into the lake of bull----!"

Sphinx

and, insufficient was the last

overburden

entered into the pit

stakeholder group

into the lake

of

bull [14]

14. CAPP, An Introduction to Oilsands Pit Lakes, p. 12, March 2021,
https://www.capp.ca/wp-content/uploads/2021/05/An-Introduction-to-Oil-Sands-Pit-Lakes-392128.pdf.

/////

Supposed to be rare
Meaning management
Unavailable for further comment
Alert, alert, alert, alert, cut off,
back-to-back
Probably extreme
Help
Floating
Switching

supposed to be rare,

meaning

management

unavailable for further comment

alert alert

alert alert

cut off

back-to-back.'

probably

extreme

help

floating

switching [15]

15. Sarah Reiger, "Hot Weather Pressures Alberta's Electricity Grid, with 2 'Rare' Alerts This Month," *CBC News*, July 14, 2021, https://www.cbc.ca/news/canada/calgary/electricity-emergency-alert-level-2-1.6103361.

/////

Prepare to strike, people!
Endless rogue waves . . .
Did you know?
This is the work:
shutdown conditions a must.

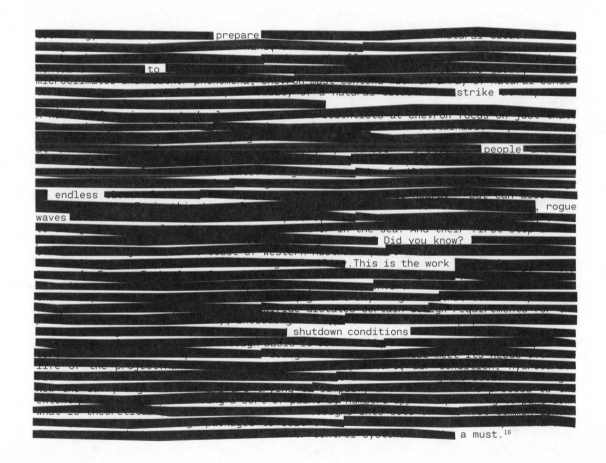

prepare
to
strike
people
endless
rogue
waves
Did you know?
.This is the work
shutdown conditions
a must.[16]

16. Chevron, "Technology and Crisis," par. 1-7, https://www.chevron.com/technology/crisis-response.

Create your own Void Spell by using the following steps:

Step 1 Choose a news clipping or short communiqué to use as source material.

Step 2 Channel your inner voice (or voids) and/or whatever frustration currently flows to the tips of your fingertips and redact, redact, redact all that must be voided in the communication.

Step 3 Leave only that which is necessary for the ritual maintenance you aim to perform in this very moment.

APPENDICES

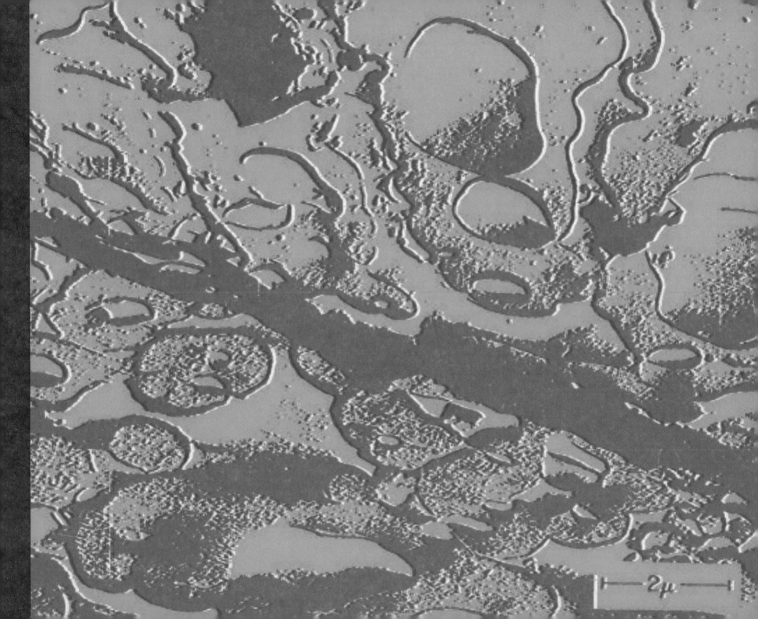
2μ

APPENDIX I
E.E.R.K. Cassette Tape Feature

Included in this Energy Emergency Repair Kit are two cassette tapes: Tape 1: Patches, which offers a variety of stop-gap measures for temporary respite from emergency conditions; and Tape 2: Fixes, which provides a comprehensive, total ███████████████ for ███████████ and ██████████████████████████████ of any and every energy emergency.

Please remember, when deploying either of these tapes, that the cassette tape medium is itself an instance and a materialization of energy transfer: the conversion of electric audio signals into magnetic energy via recording and then, during playback, of that magnetic energy back into audible electrical energy. Such energetic conditions are not at all permanent, even though magnetic hysteresis--the dependence of the state of a given magnetic system on its history--will suggest that spectral energetic traces might always remain. Instead, these conditions are relational, mediate, dynamic: contingent on the polarities orienting magnetic particles within the tape's binder and also on the encounters and engagements in time between sonic waves and cochleae. Accordingly, a cassette tape's energetic circuits remain subject to bias, distortion, noise, and decay.

CAPABILITIES: Will transmit novel tones and rhythms to generate haptic feedback, seed proleptic memories from the future anterior, inspire communitarian becomings, and encourage hearing otherwise.

Will not promote greenwashing fantasies, longings, or tolerances of any sort.

AFFORDANCES: Four sides of meditative and/or provocative sonics designed to inspire bliss, rage, and joy; bold red casing aids retrieval in event of tape misplacement.

MAXIMUM CONSEQUENCE FROM USE: Pro tem stopgaps for immediate emergency relief on Patches tape; ██████████████████████████ and ██████████████ on Fixes tape.

BASIC SET-UP

Remove desired tape from enclosure in kit. Insert tape, first side up, into cassette tape player.

BASIC LISTENING OPERATION

Press play on cassette tape player. Listen to first side. Once finished, flip tape and repeat process for second side.

ADVANCED PRODUCT FEATURES

Easy rewind for review, note-taking, and study-group purposes.
Double-sided flipability discourages caution, invites risk-taking.
Custom stop-or-pause to facilitate use in any emergency situation.
Whispertek coating to minimize risk of cross-talk.

PRODUCT MAINTENANCE

Keep tapes in enclosure slots when not in use. To clean cassette casing, gently buff with soft chamois. Avoid contact with liquids of any sort.

TROUBLESHOOTING

Over time, exposure to moisture may cause the E.E.R.K. cassette tapes to begin to exhibit signs of sticky-shed syndrome: tearing sounds, whining or squealing noises, and generalized sluggishness. It is possible to reverse this syndrome, albeit only temporarily; see Appendix III for details.

APPENDIX II
E.E.R.K. Cassette Tape Tracklists

TAPE 1: PATCHES

Side A: In Case of Emergency

01: De/familiarization
02: Signal Boosts
03: NSOPs
04: Ritual Maintenance

Side B: Contact Tracings

01: Breathing
02: External Respiration
03: Gas Transport By Blood
04: Internal Respiration
05: Cellular Respiration

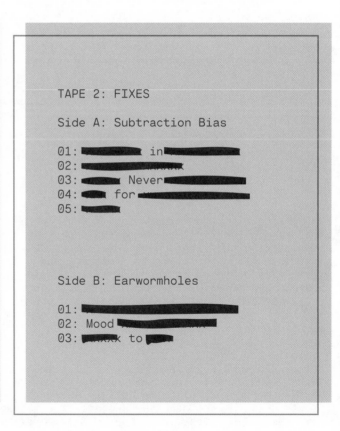

TAPE 2: FIXES

Side A: Subtraction Bias

01: ████████ in ████████
02: ████████████
03: ████ Never ████████
04: ██ for ████████████
05: ████

Side B: Earwormholes

01: ████████████████
02: Mood ████████████
03: ████████ to ████

APPENDIX III

Tape Baking Recipe (Perpetual Un | Fixing)

As noted in Appendix I, excessive or prolonged exposure of the E.E.R.K. cassette tapes to moisture can eventually result in the onset of sticky-shed syndrome (S3). S3--also termed sticktion--occurs when the adhesive binder that suspends the magnetizable particles (whether ferric oxide or other material) deteriorates through hydrolysis, compromising the tape's performance. The following symptoms of S3 can appear during rewind or playback:

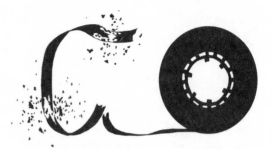

~ *tearing, screeching, or squealing noises;*
~ *flaky, rusty, scurfish leavings;*
~ *gummy residue;*
~ *intermittent sonic dropouts;*
~ *general tape sluggishness or petulance.*

Two options exist for attempting to reverse S3: 1) heating or 'baking' the affected tape; 2) dehumidifying the surrounding environment. The former solution, while merely temporary and potentially damaging to the tape or its casing, is strongly preferred by the E.E.R.K. team, since the latter method not only takes much longer but also encourages the sort of technoutopian environmental geoengineering rejected by team members on principle.There exists no standard tape-baking protocol--the practice is indeed more art than science. Through sustained research, not to mention considerable trial and error, the E.E.R.K. team has honed the following recipe, which it recommends with confidence as a means of temporarily repairing all S3 symptoms without damage to either tape or casing.

STEP 1: Heat oven or comparable baking device to a low, steady temperature: 130 to 140 °F (54 to 60 °C).

STEP 2: Place afflicted cassette tape stock directly on the oven rack or on a baking tray lined with wax paper.

STEP 3: Bake tape, turning occasionally, for 1 to 8 hours, depending on extent of S3 damage (see notes below for additional variables relevant for time of baking).

STEP 4: Let cool for at least 30 minutes.

STEP 5: Enjoy listening to tape free of S3 symptoms.

NOTES

A toaster oven, crock-pot, or food dehydrator are acceptable alternatives to a standard oven for baking purposes. Regardless of device, do not try to bake foodstuffs alongside tapes, no matter how hungry you are or how much time and energy you can save.

Do not use a microwave oven, electric frying pan, fondue pot, panini press, hot air popper, Bunsen burner, blowtorch, wood-burning stove, or backyard fire pit to attempt to bake tapes. Such devices are appropriate for tape roasting, searing, frying, crisping, broiling, or melting only.

Avoid huffing or otherwise savoring the sweet acrid smell of the baked tape as it cools, since chemicals off-gassed from its casing are probably toxic.

Several factors can influence the time required to bake a tape successfully:

~ width and length of tape substrate;
~ extent and reach of tape hydrolysis;
~ viscosity or lubricity of moisture affecting tape;
~ predominant sonic frequency of tape in question, with lighter, delicate highs (string quartet, birdsong, music of the spheres, etc) needing less time at the lowest temperature, and heavier, grinding lows (sludgecore, landslide, NASCAR, etc) permitting more time at a higher temperature;
~ the tendency toward fidelity or treachery of tape in question.

Tape baking is a merely pro tem solution to the problems of S3. In this respect, it constitutes more patch than fix. Accordingly, it is wise to consider transferring the tracks from a newly baked tape to a surrogate as soon as possible. Baking the same tape repeatedly will yield diminishing returns.

The temporariness of tape baking holds uncomfortable implications for the cassette tape as an energetic medium, since it will suggest that magnetized sonic memory is inescapably imperfect and impermanent. The future is ultimately unfixable, no matter what speculative hedge, short, or squeeze one chooses to venture. Hence it is worth wondering, before undertaking to bake a tape, whether it might not make more sense to learn to live with energetic contingencies of distortion, entropy, signal loss, and decay.

Correspondence Contact Tracing

The following scatter plot exhibits a selective trace through the E.E.R.K. Team's email threads between March 2020 and May 2021 wherein Y=expression & X=time. Red dots indicate the frequency of expression, and emojis are tracked across the X axis only.

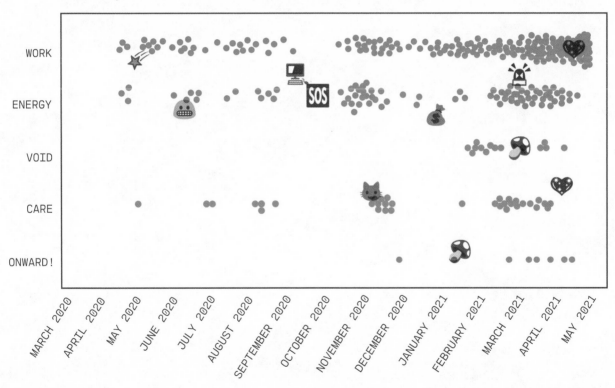

This page intentionally left blank. Energy unavailable <3 <3

This page intentionally left blank. Rental opportunities <3 <3

E.E.R.K.

Technical Writers, Designers, & Schemers:

Joan Greer
Lisa Moore
Sourayan Mookerjea
Mark Simpson
jessie beier
Tṣēmā Igharas
Tegan Moore
Catlin W. Kuzyk
Jerome Tavé
Kyle Lawson

Initially published by:
Speculative Energy Futures

First printing by: Vide Press, Toronto

Back Matter

The E.E.R.K. Collective is a comradely crew of artists, designers, and scholars from across Turtle Island who conspire with multitudinous experts–mycelial spores and artisanal fabulators, ferromagnetic attractors and recording engineers–in a perpetual practice of decomp poesis: speculative energetic encounters that proliferate care and repair by deviating the designs.

Core members include:

Joan Greer, PhD Vrije Universiteit, Amsterdam (Professor Emerita, University of Alberta), who teaches the History of Art, Design, and Visual Culture. Her research engages with issues of artistic identity, landscape art, the history of environmentalism, and theories of nature and ecological envisioning, both historically (most particularly in the long nineteenth century) and in contemporary art and design, with a special interest in The Netherlands and Belgium. Her ongoing major research project is entitled "Visualizations of Nature in Nineteenth-Century Dutch Print Culture: Religion, Science, Art." For this work, as well as her research-creation projects, she has developed theories of Ecological Envisioning and of Compostual Thinking. These pursuits overlap with investigations of historical and contemporary representations of pollination and insect ecologies.

Sourayan Mookerjea, Professor of Sociology and research director of the Intermedia Research Studio in the Department of Sociology, University of Alberta, in Treaty Six Territory. His areas of research include intermedia research-creation, critical and anti-oppression social theory, global sociology, political ecology, and energy humanities. His research addresses questions of ecological debt, the cultural and class politics of renewable energy system change, and engages critically with eco-feminist degrowth theory, specifically on the question of delinking from the world-ecology of racial capitalism and from the colonizers' models of the world. He is co-director of Feminist Energy Futures Powershift and Environmental Social Justice and iDoc: Intermedia and Documentary as well as a co-investigator on the research-creation collaboration Speculative Energy Futures. He is a member of the Feminisms and Degrowth Alliance Writing Collective and education coordinator for Climate Action@University of Alberta.

Mark Simpson, a settler scholar and professor in the Department of English and Film Studies at the University of Alberta (Treaty Six / Métis Territory) who investigates US culture, energy humanities, and mobility studies. Recent examples of his scholarship have appeared in journals such as *South Atlantic*

Quarterly, Radical Philosophy, Postmodern Culture, and *English Studies in Canada,* and in volumes from presses such as Minnesota, Fordham, Edinburgh, Toronto, McGill-Queen's, and Oxford. He is a co-founder of the After Oil Collective and a core member of the Petrocultures Research Group.

jessie beier, a teacher, artist, researcher, philosopher, and conjurer of weird pedagogies for unthought futures. Working at the intersection of art, philosophy, and pedagogy, jessie's research-creation practice aims to mutate and upend dominant visions of educational futurity so as to speculate otherwise on pedagogical possibility in an era of ecocatastrophe. She is the author of *Pedagogy at the End of the World: Weird Pedagogies for Unthought Educational Futures* (Palgrave Macmillan, 2023) and co-editor of two collections: *Sound Research for Troubling Times: Hope in Crisis* (with Owen Chapman, Palgrave Macmillan, 2024) and *Ahuman Pedagogy: Multidisciplinary Perspectives for Education in the Anthropocene* (with jan jagodzinski, Palgrave Macmillan, 2022).

Tsēmā Igharas, an award-winning interdisciplinary Tāltān artist, living and working between Ohlone Lands in Oakland, California, and Tahltan Territory in Northern Canada. Tsēmā creates artwork that connects materials to mine sites and bodies to the land citing her Indigenous mentorships, Potlatch, and studies in visual culture. She has studied at K'saan, Emily Carr University of Art and Design, and earned an Interdisciplinary Masters of Art Media and Design from OCADu. Tsēmā has exhibited and performed in Canada and internationally and, notably, has had her work published in *Art in America, ARTFORUM, Women and Performance: A Journal of Feminist Theory* and *Canadian Art Magazine.* Writing credits include the artist's thesis, LAND|MINE (OCAD, 2016) and recently, co-authorship of the article "Ice Patches and Obsidian Quarries: Integrating Research through Collaborative Archaeology in Tahltan Territory" (*The Journal of Field Archaeology*, 2023).

Tegan Moore, an artist working in sculpture and installation, currently living and working in Tio'tià:ke/ Mooniyang/Montréal. She has a practice of salvage and re-use which examines the complexities of materials related to the built environment. She also works collaboratively with plastic pollution research group The Synthetic Collective. Recent exhibitions include *Le synthétique au cœur de l'humain,* Canadian Cultural Centre, Paris (2023), *Plastic Heart: Surface All the Way Through* at the Art Museum at the University of Toronto (2021), and *Foam Fatigue* at YYZ Artists' Outlet, Toronto (2021). Her work has

been published in *Canadian Art Magazine*, CBC's *The National*, *ESSE Revue*, *Momus*, and *The Science of the Total Environment*.

The Energy Emergency Repair Kit would not exist without brilliantly collaborative and generative contributions from Catlin W. Kuzyk, who brought sonic alchemy to the project playlists, and from Jerome Tavé and Kyle Lawson, who delivered illustration prowess, design magic, and mycelial wonder from their base at 10th Floor Studio. Special thanks as well to Lisa Moore for inspirational exchanges in the project's formative early moments.

The project began as a limited-edition set of 30 binders produced, under the auspices of a multi-year research project called Speculative Energy Futures (SEF), as one component of a larger, multimodal FluxKit for Energy Transition. The E.E.R.K. Collective is forever grateful to Sheena Wilson and Natalie Loveless for their visionary leadership of SEF. A huge shout out to the whole SEF crew for the motivating energies you bring to the collective, collaborative practice of research-creation!

Deep and abiding gratitude to Richard Morrison, our wonderful editor at Fordham, for seeing the promise in our weird thing and then supporting it so resolutely. Richard: your belief is a great source of energy! Thanks as well to our reviewers, Ricardo Dominguez and Tommy Davis, who gave us courage by endorsing our project and embracing its commitments.

This research was supported by funding from the Canada First Research Excellence Fund as part of the University of Alberta's Future Energy Systems research initiative.